66 ON 66

A PHOTOGRAPHER'S JOURNEY

TERRENCE MOORE

WITH FOREWORD BY MICHAEL WALLIS
AND AFTERWORD BY CLARK WORSWICK

All photographs copyright ©2018 by Terrence Moore
Foreword copyright ©2017 by Michael Wallis
Afterword copyright ©2017 by Clark Worswick

First Hardcover Edition
Printed and bound in the US and China

Cover and Interior Design: Jordan Wannemacher
Design Consultant: Clark Worswick/Midnight Books
Film Editing: Suzi Moore-McGregor

ISBN: 978-1943156-70-2

Front Cover Photo: Grandview Motel on Nine Mile Hill, Albuquerque, New Mexico 1988
Back Cover Photo: Ford Wagon Rolling Into Erik, Oklahoma 2006

For Linette, Charles, and Cassius

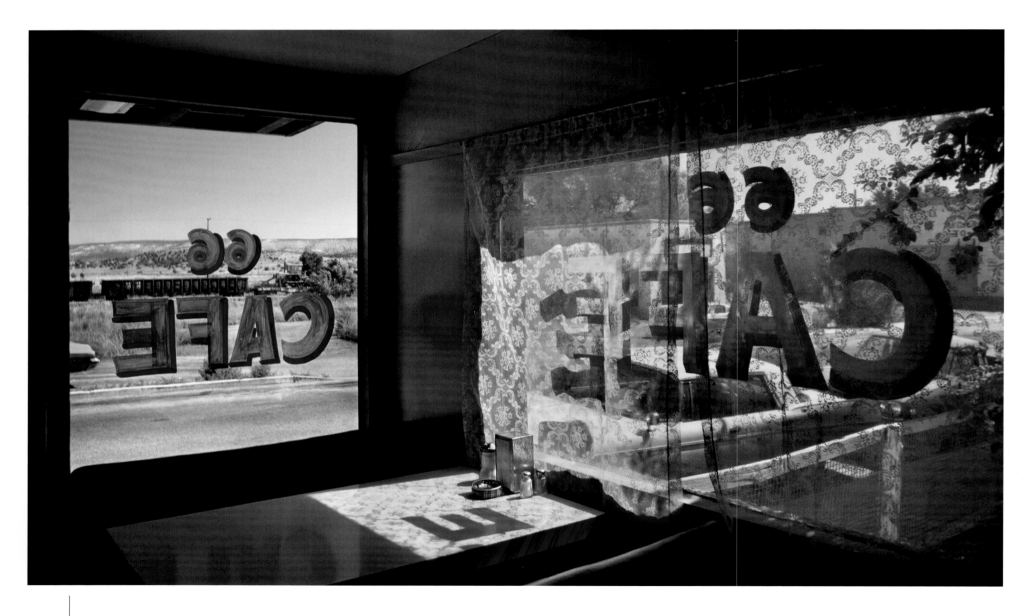

66 Cafe, Ashfork, Arizona 1976

FOREWORD

DURING THE COURSE of my career as a journalist and author I have had occasion to work with some truly outstanding photographers. Many of them have won major awards and received international acclaim for their impressive bodies of work.

In my book, none of them — not a single one — measures up to Terrence Moore. When it comes to the actual process of creating an image no one can surpass him. Moore's quiet approach to a subject, his laser-sharp eye, and gentle touch result in stunning photographs that become unforgettable moments captured forever in time and memory.

Moore handles a camera with the same passion and focus as Hendrix or Clapton making love to a guitar. He is an authentic maestro.

Moore's many achievements result from a combination of talents and skills that a photographer must possess in order to be successful. He is curious, well prepared, works quickly but with great efficiency, and is disciplined.

Also, Moore understands light — the key ingredient for a photographer on the prowl. He knows how to find light and use it to create images that tell a story and never lose their relevancy.

Moore's subjects include architecture, landscape, Americana, and portraiture ranging from cowboys to heads of state. His approach is the same whether he is photographing rednecks or blue bloods, a crumbling adobe or a cathedral, the concrete canyons of a city or the quirky towns along Route 66.

Of course, it is Route 66 — a bastion of Americana lost and found — that remains one of the primary passions that I share with my good compadre. Terry Moore is the dean of Mother Road photographers. He has been photographing Route 66 for almost fifty years. I was fortunate and honored that so many of his images grace the pages of my book, *Route 66: The Mother Road*, the work credited with the incredible revival of interest in the historic highway.

You are about to discover that what I have written about Terrence Moore is true. You will not be disappointed.

Michael Wallis
January, 2018

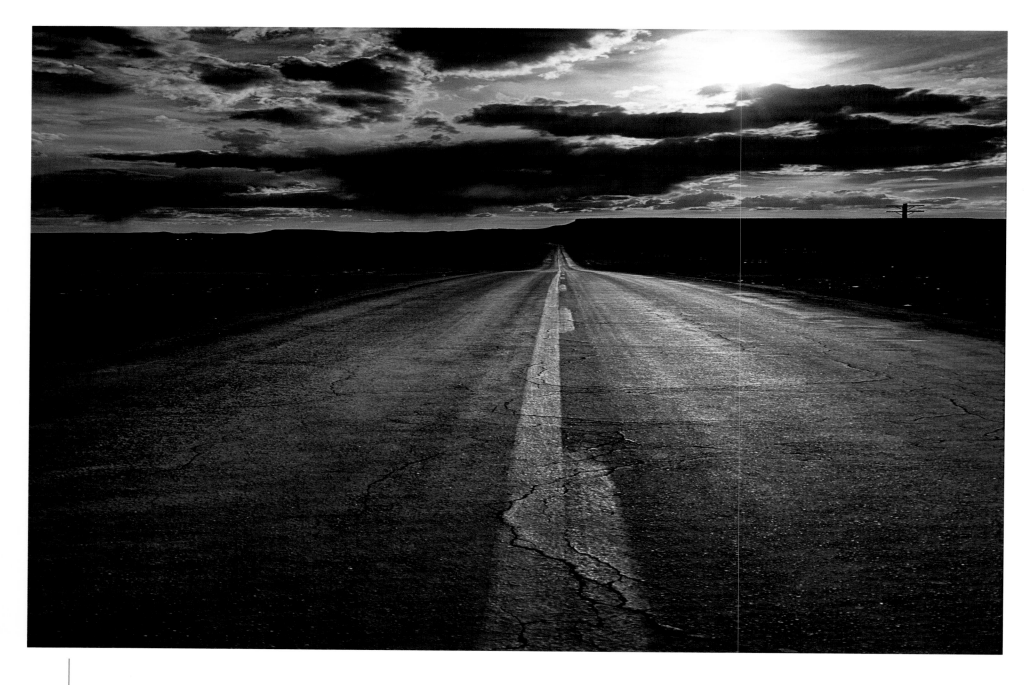

Heading west from San Fidel, New Mexico 1971

THE MOTHER ROAD

66 Neon

Elk City, Oklahoma 2006

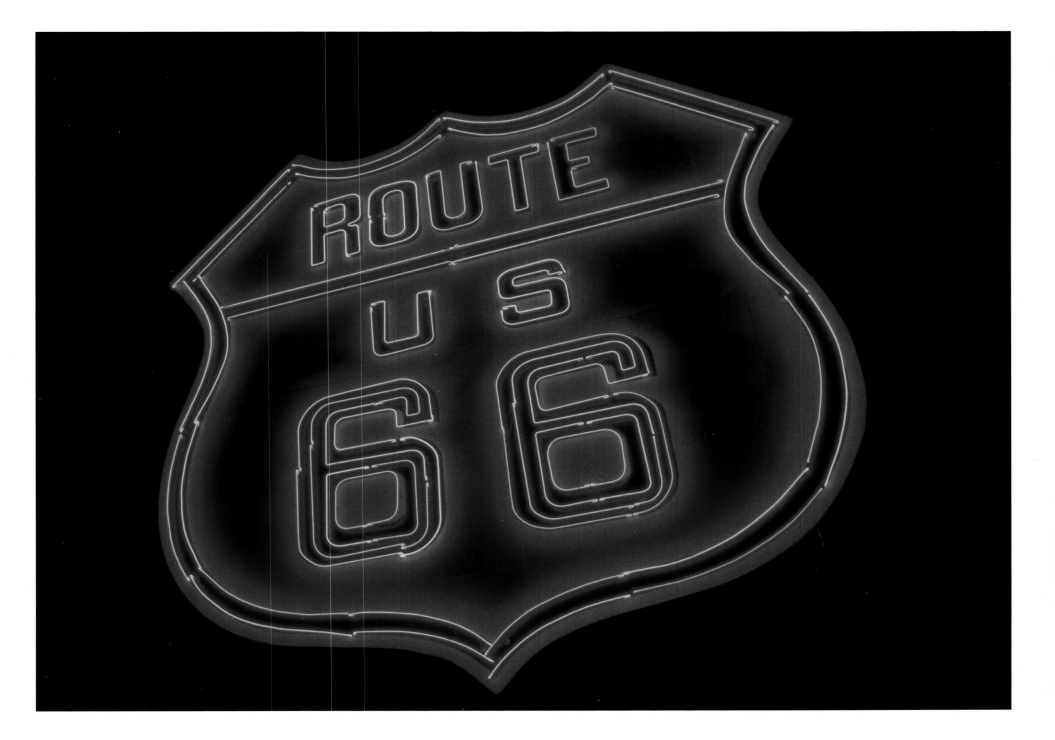

U.S. Hwy. 66 west of Tucumcari, New Mexico 1984

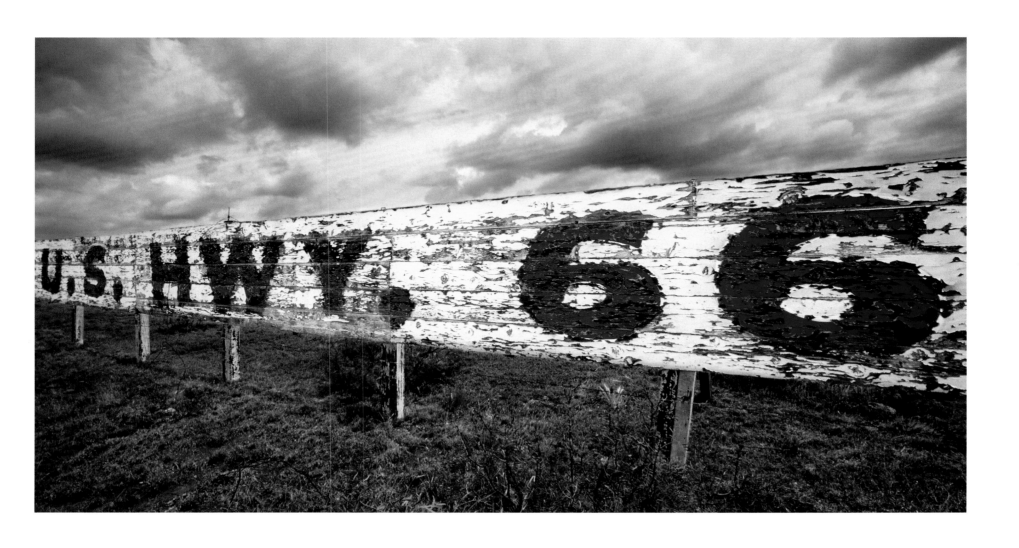

66 Road Sign

Texas Panhandle 1973

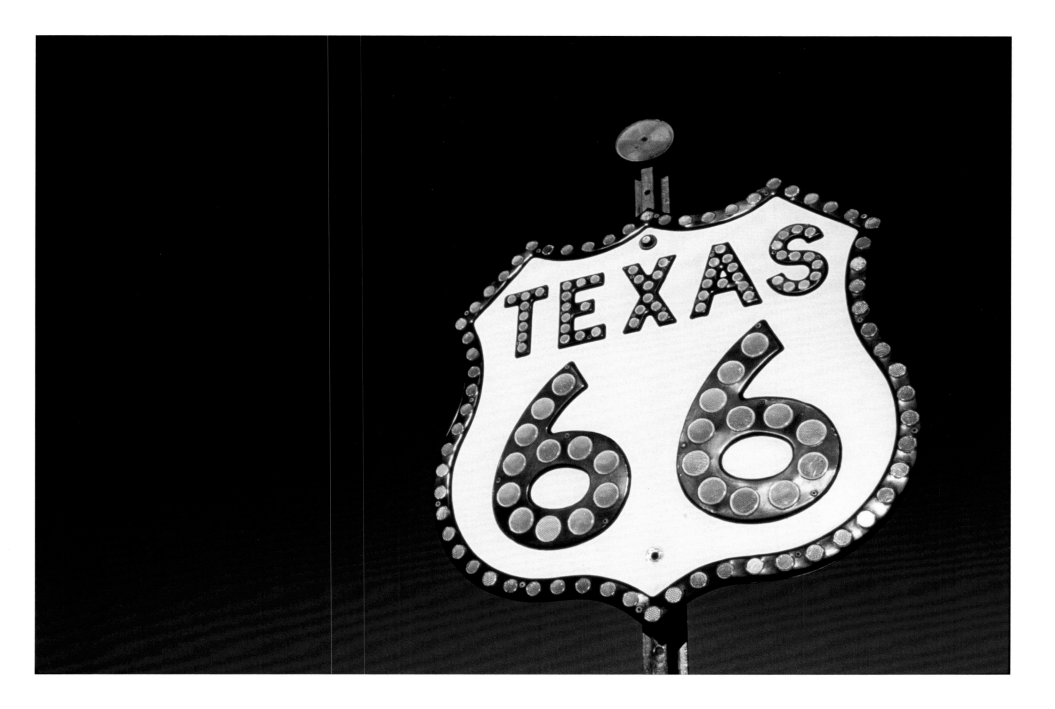

Kachina

Winslow, Arizona 1972

Old Highway between Cuervo and Santa Rosa, New Mexico 1984

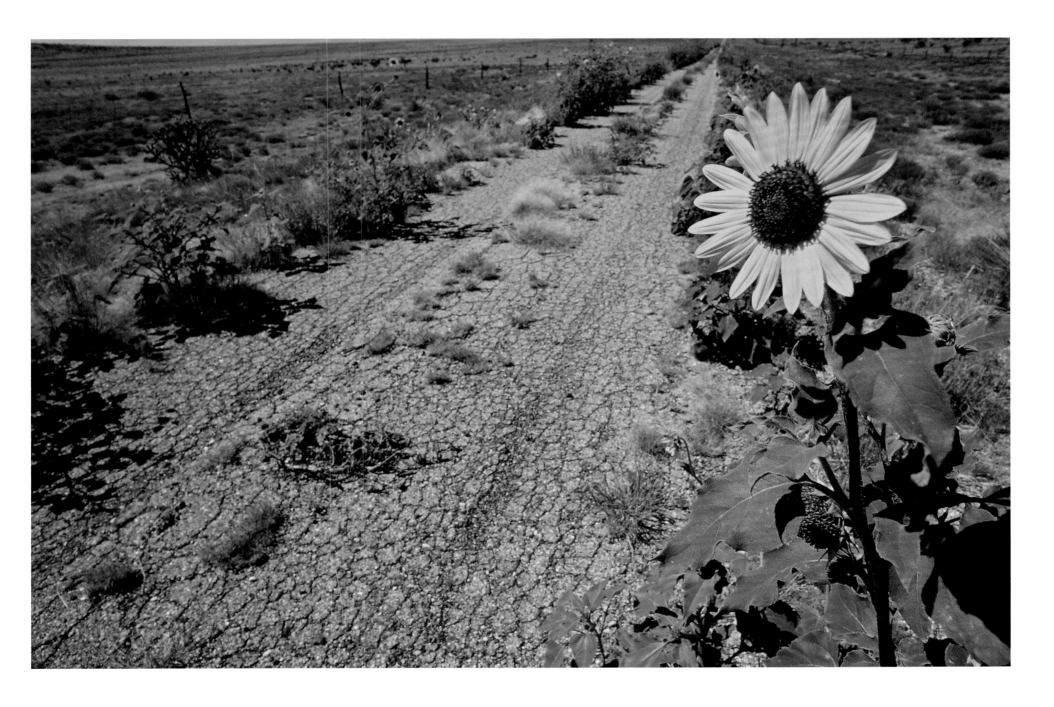

Chief Yellowhorse
Lupton, Arizona 1972

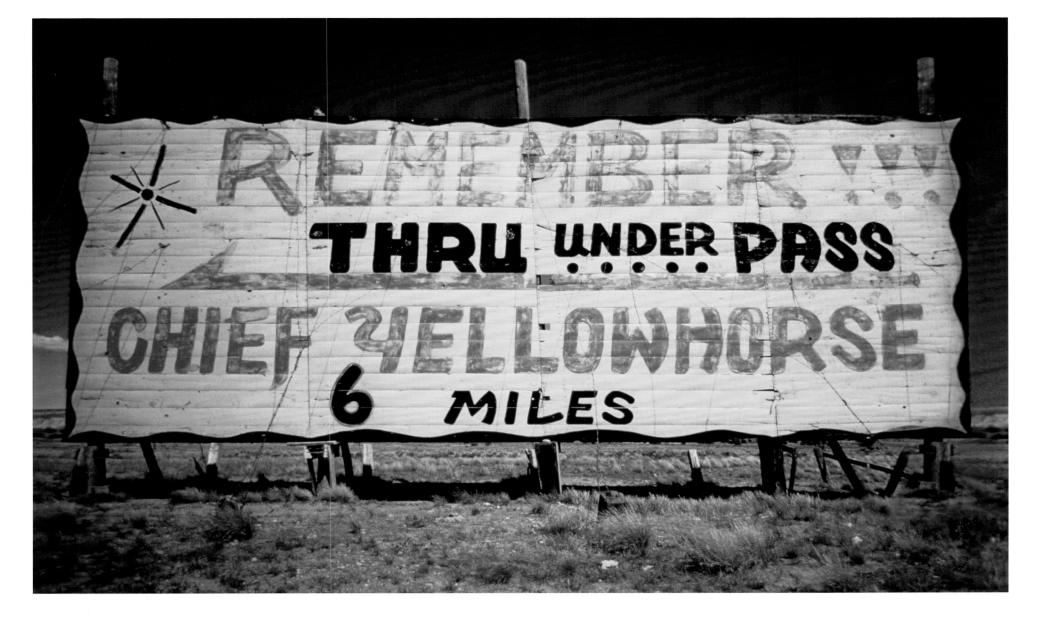

Desert Hills Bar and Trading Post

West of Albuquerque, New Mexico 1971

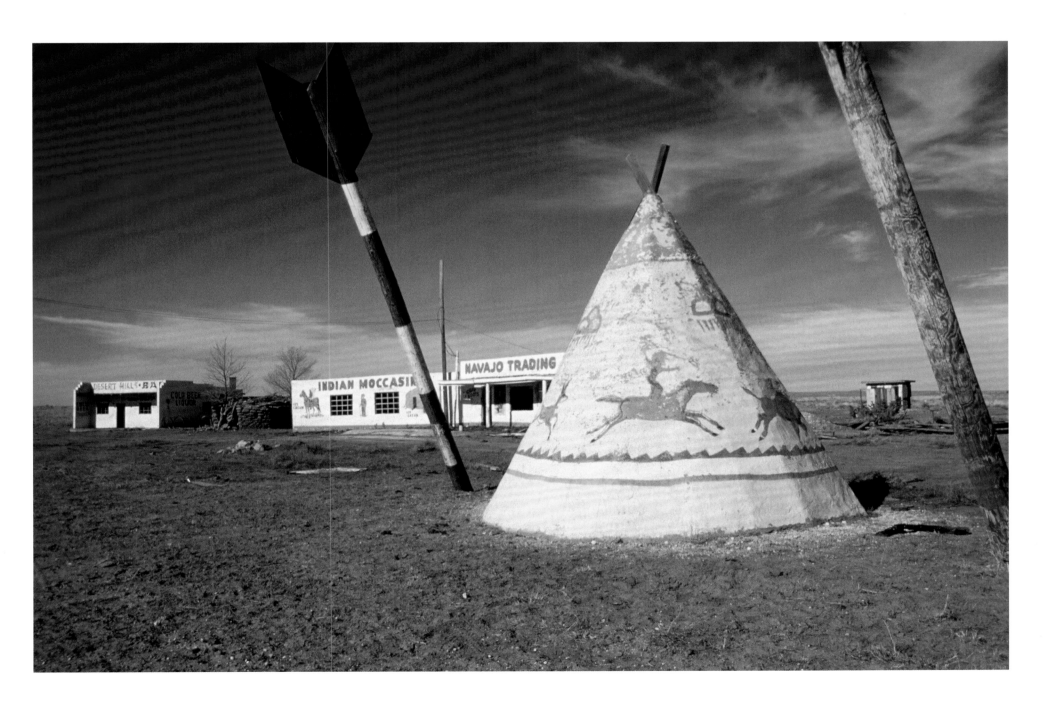

Pop 5¢

San Fidel, New Mexico 1971

Indian Curios, Navajo Rugs

Algodones, New Mexico 1972

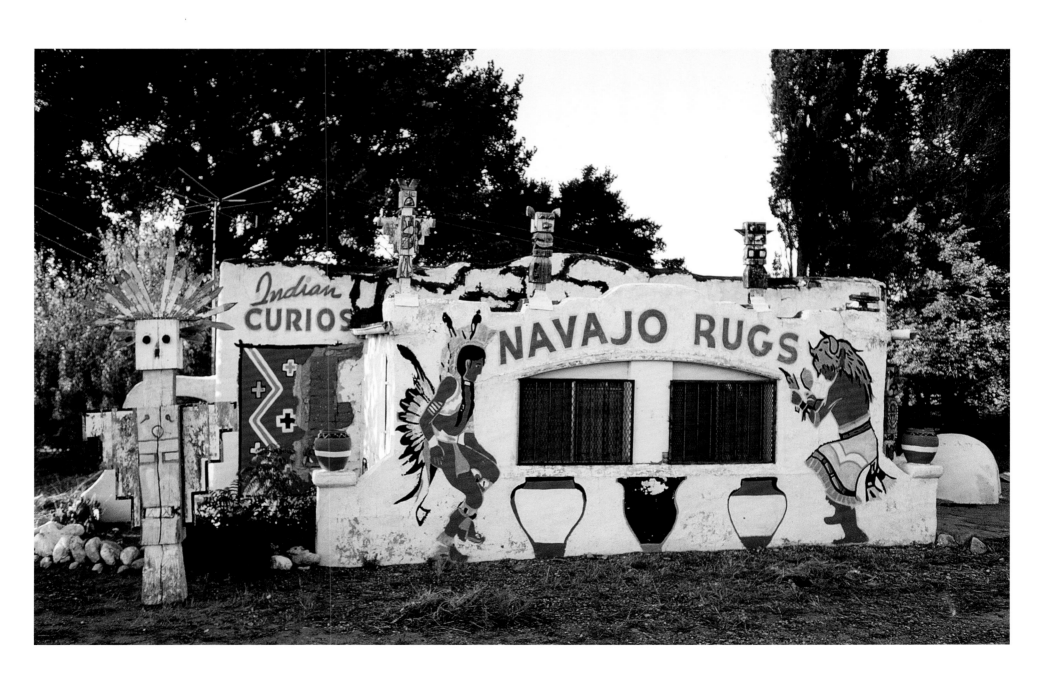

Navajo Motel

Holbrook, Arizona 1974

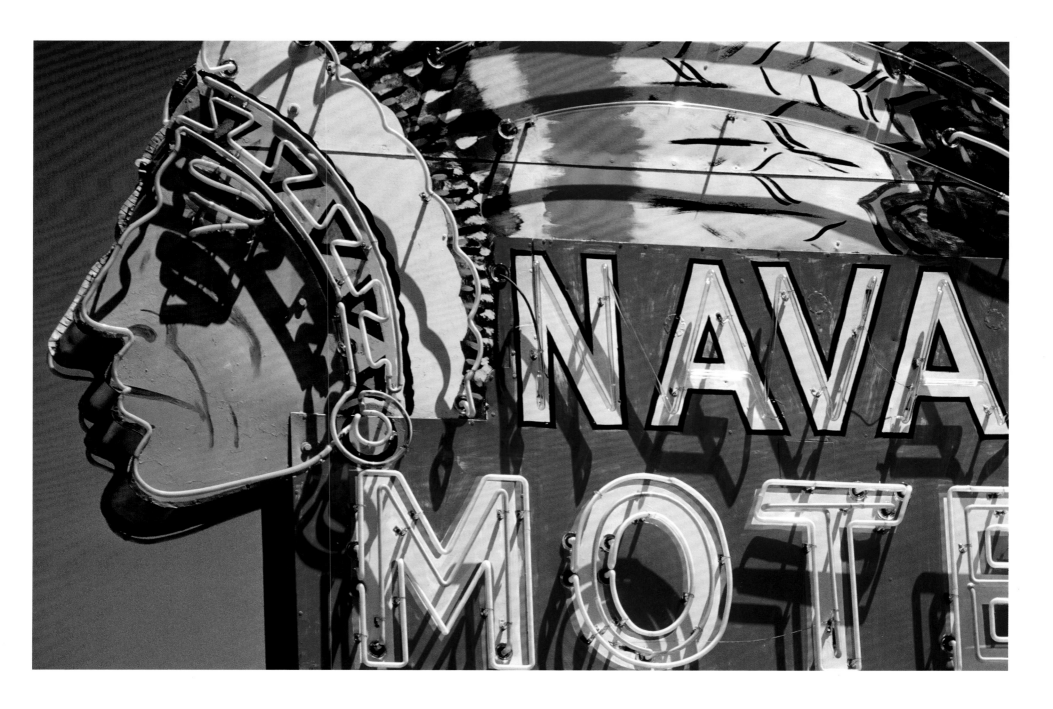

Regal Reptile Ranch

Alanreed, Texas 1976

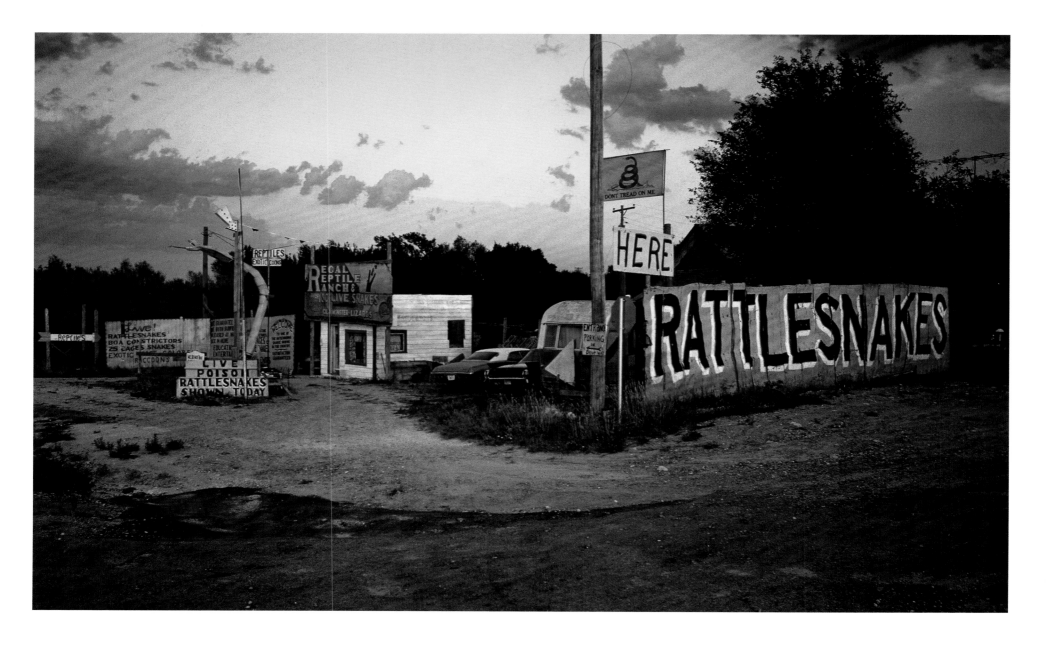

Arrowhead Liquors
Winslow, Arizona 2004

Phillips 66 Sign

Oklahoma 1984

Navajo & Hopi Art Center
Winslow, Arizona 1972

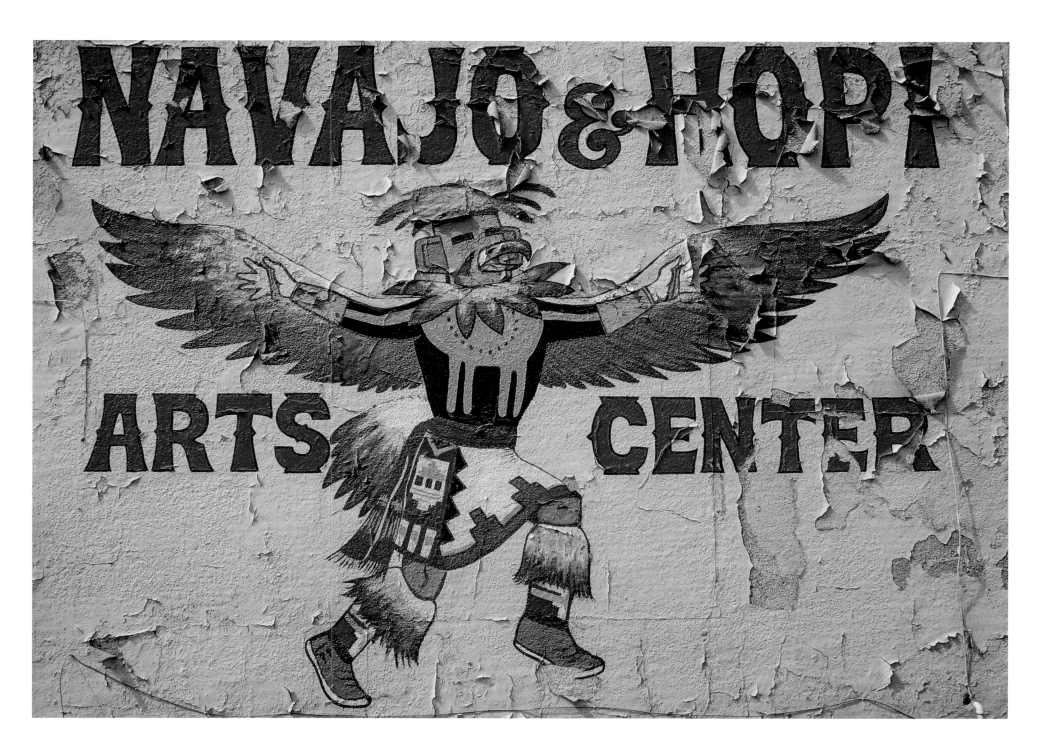

Villa de Cubero Cafe

Cubero, New Mexico 1971

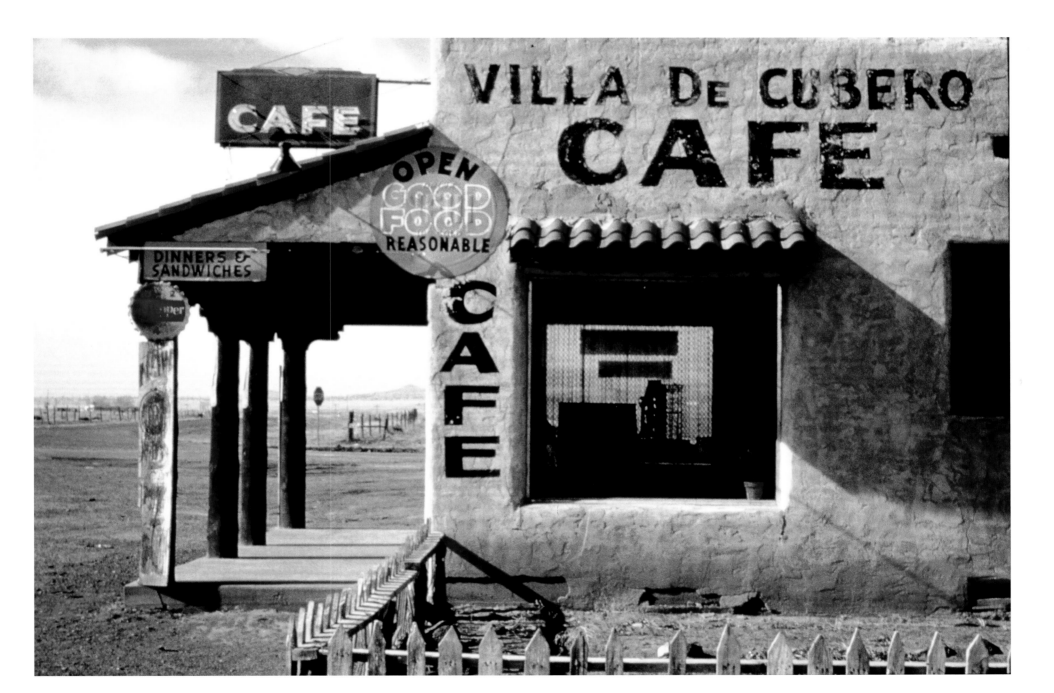

Woman-eating Dinosaur

East of Holbrook, Arizona 1999

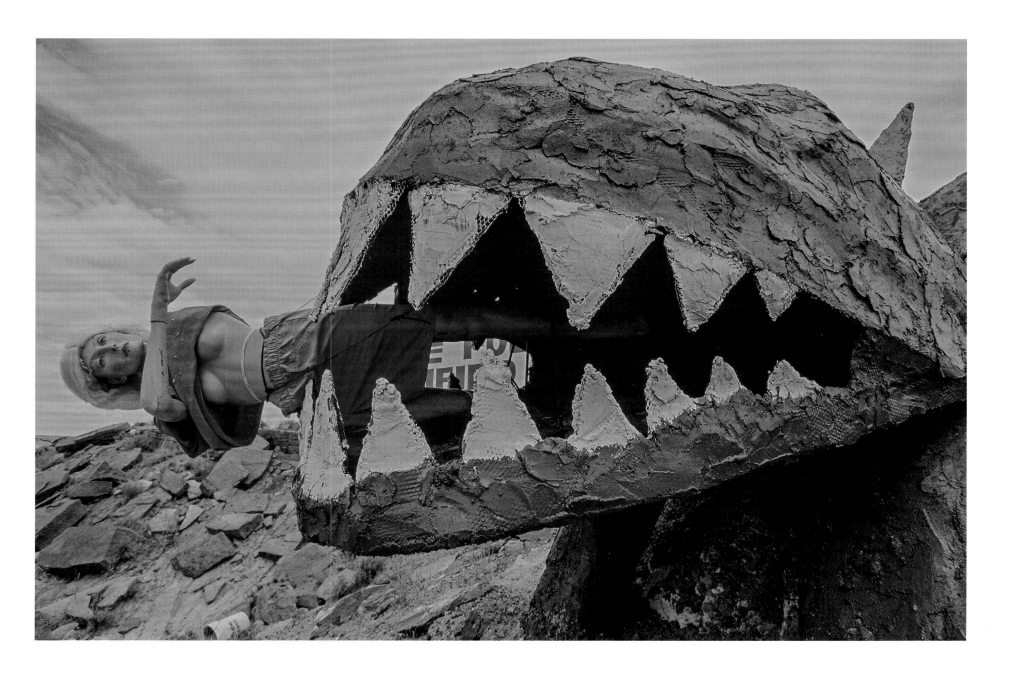

Cowboy and Horse

Tucumcari, New Mexico 1984

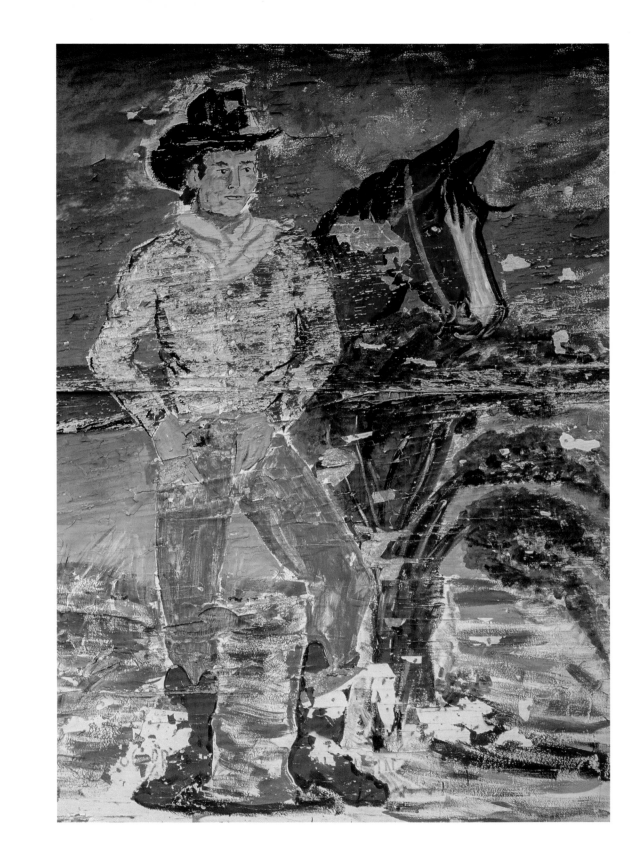

Grandview Motel on Nine Mile Hill
Albuquerque, New Mexico 1988

Flying M Ranch Motel

Tucumcari, New Mexico 1976

El Vado Motel

Albuquerque, New Mexico 1980

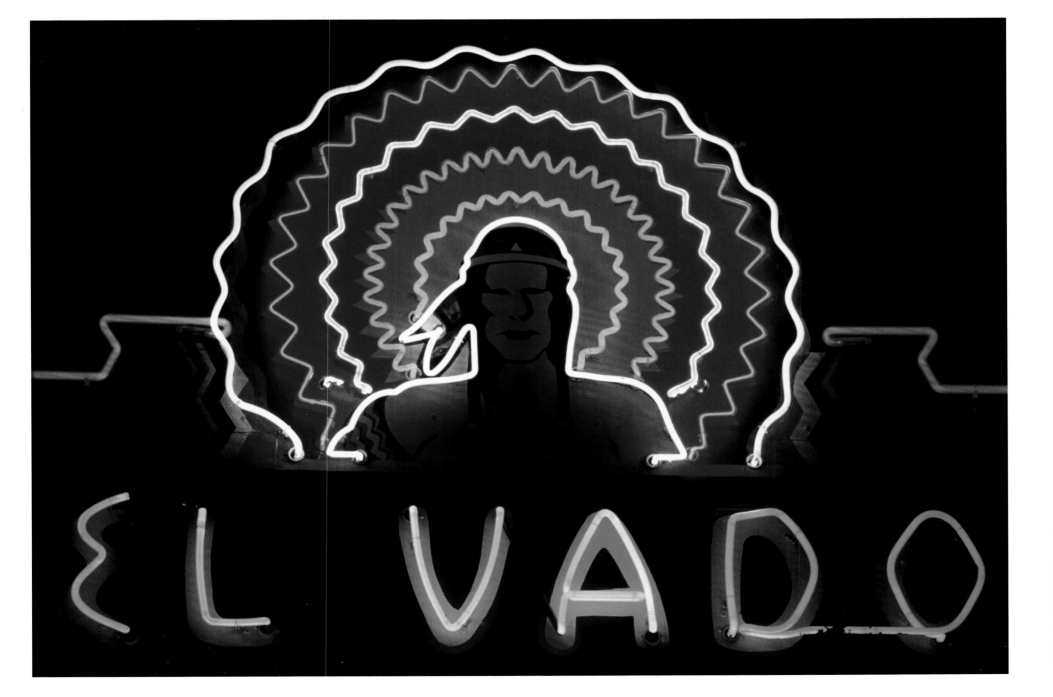

Hotel Monte Vista

Flagstaff, Arizona 2012

Neon Indian

Gallup, New Mexico 1980

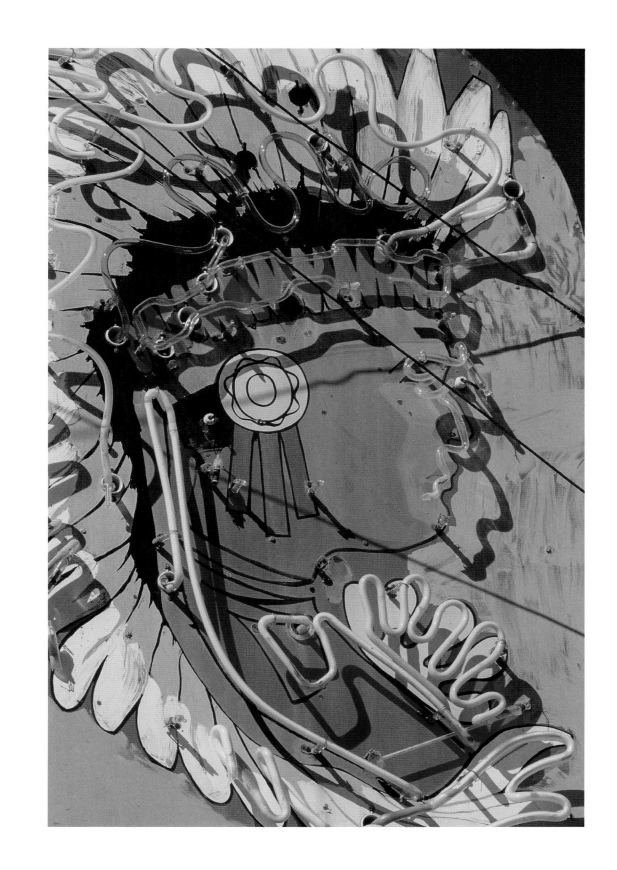

Palomino Motel

Tucumcari, New Mexico 1976

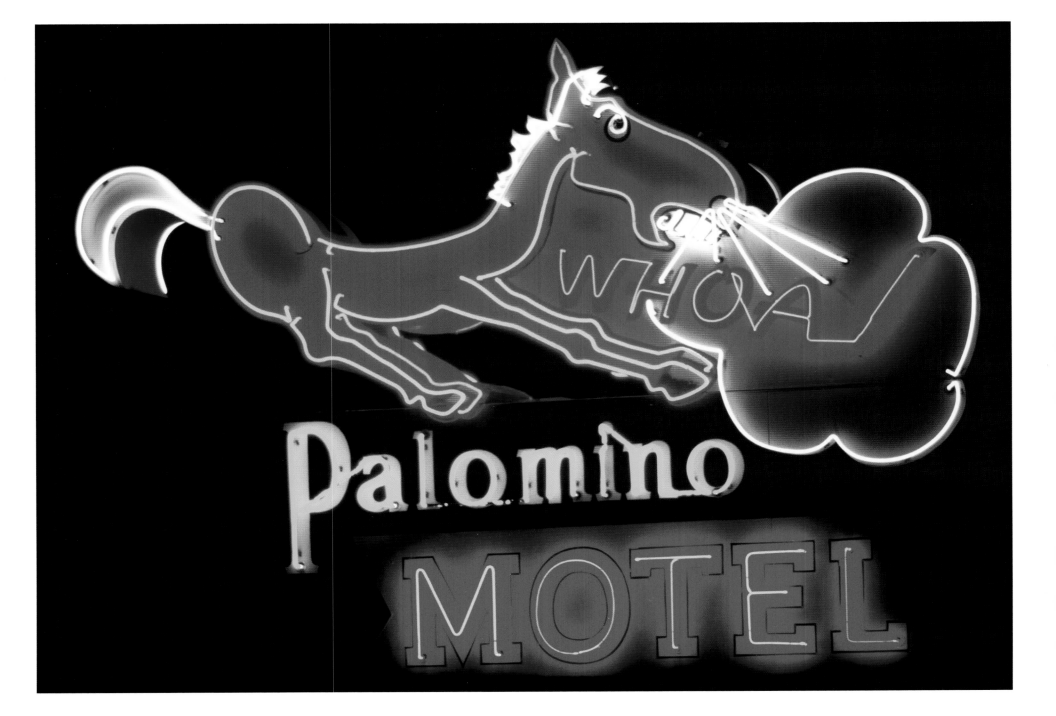

HERE IT IS
Jackrabbit, Arizona 1978

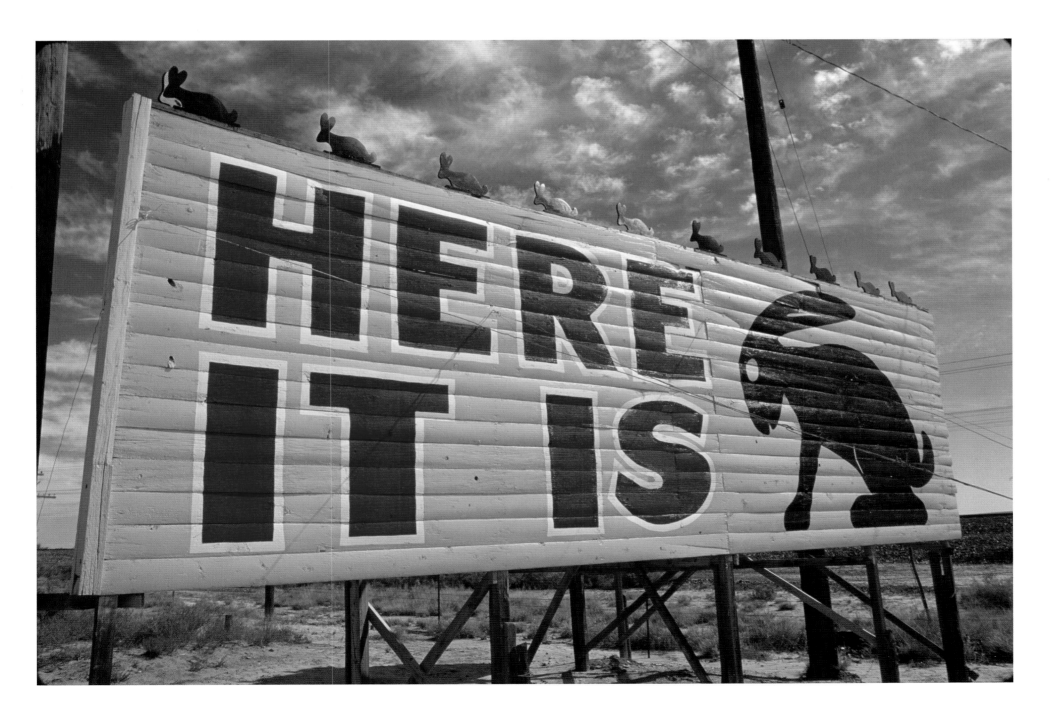

Cowboy Motel

Amarillo, Texas 1982

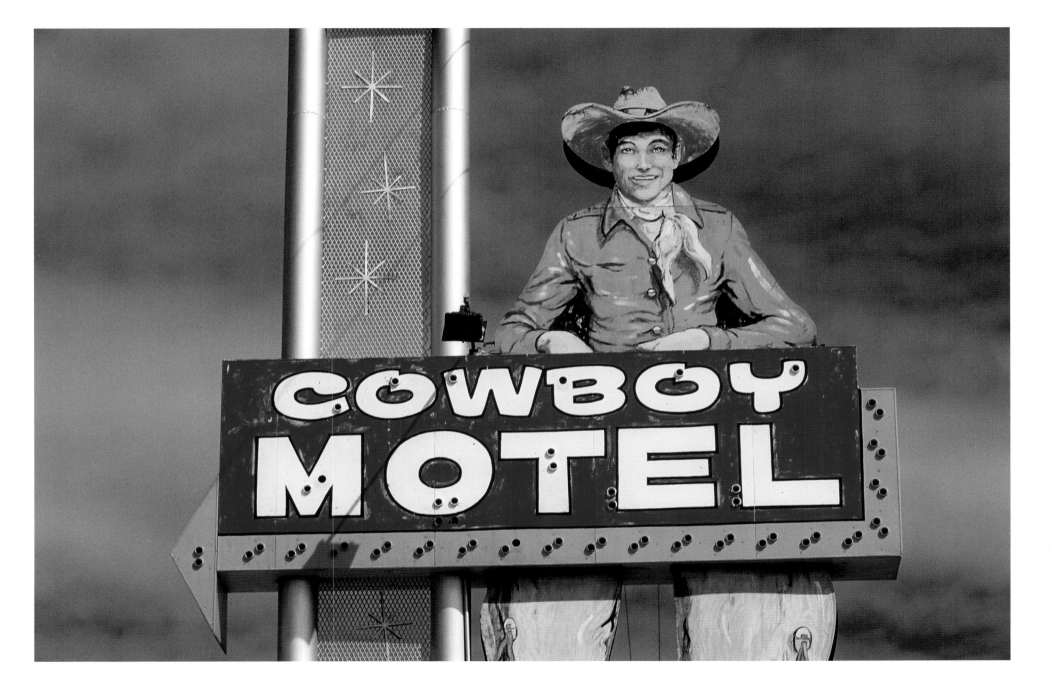

El Corral Motel

Victorville, California 2008

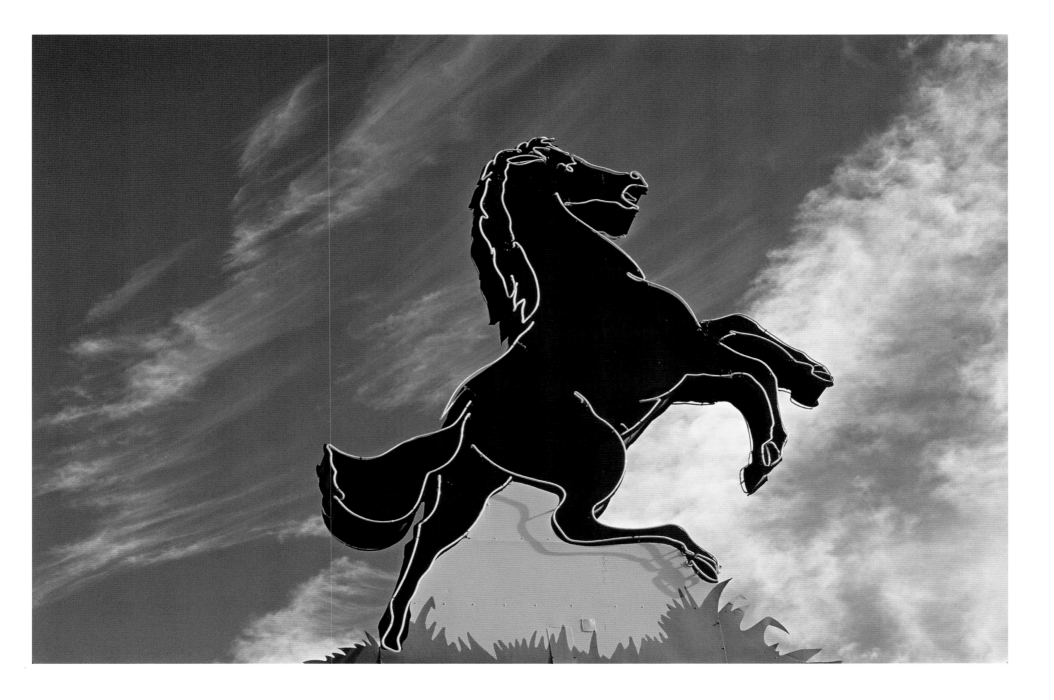

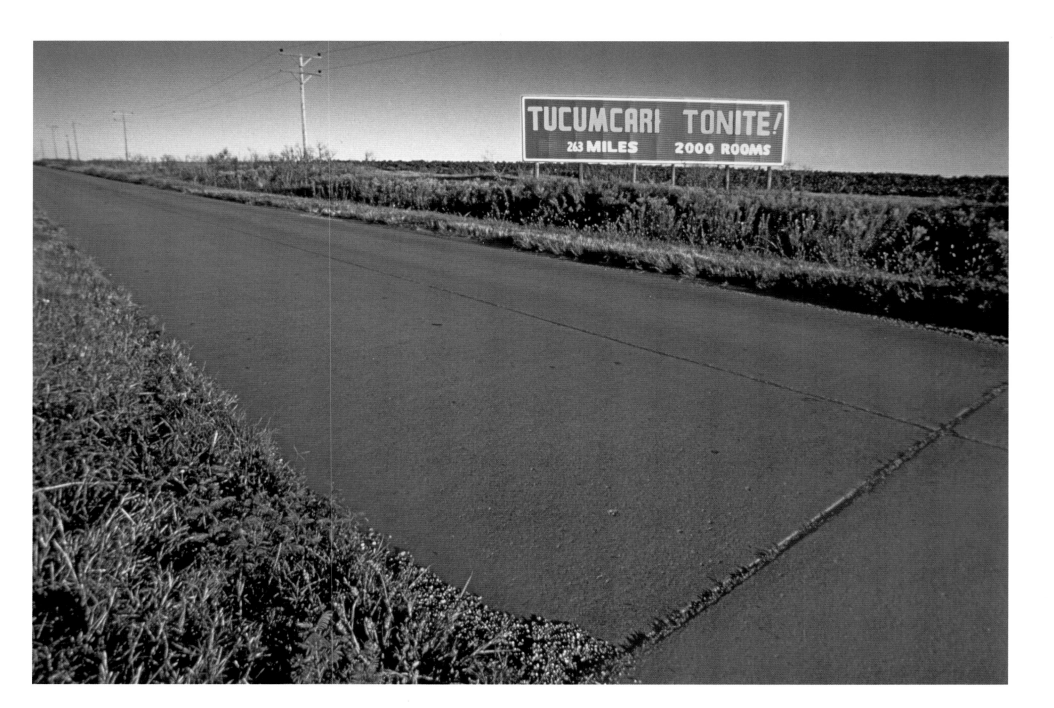

Breath Deeply, Folks

Topock, on the Colorado River 1976

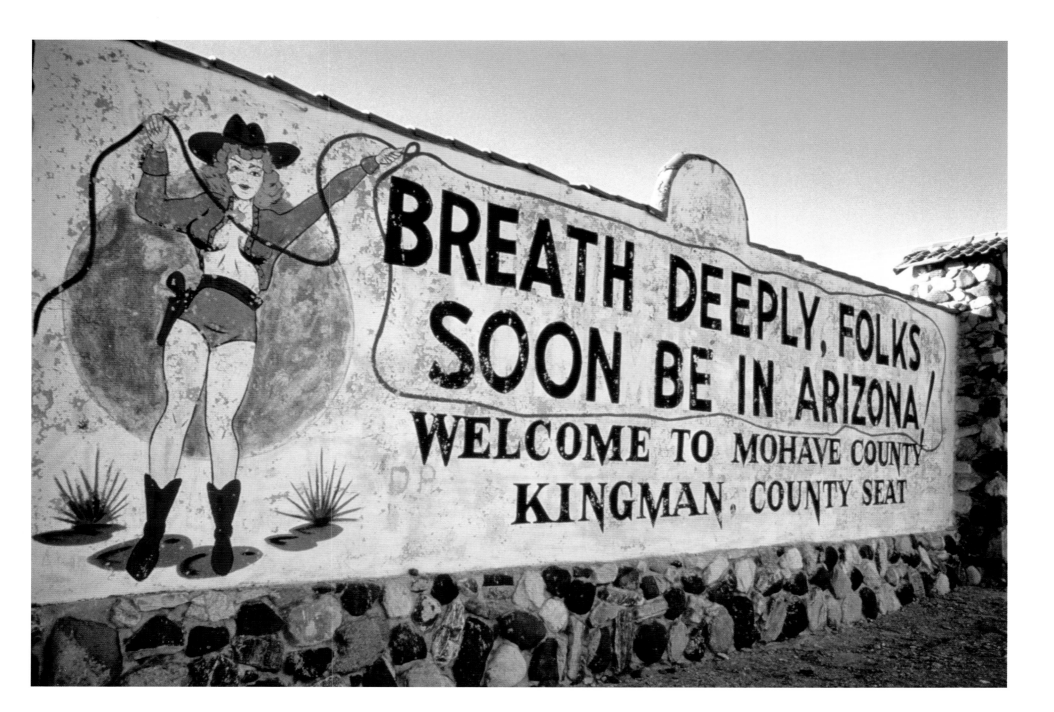

Kingman Club

Kingman, Arizona 1999

Santo Domingo Trading Post
Santo Domingo, New Mexico 1972

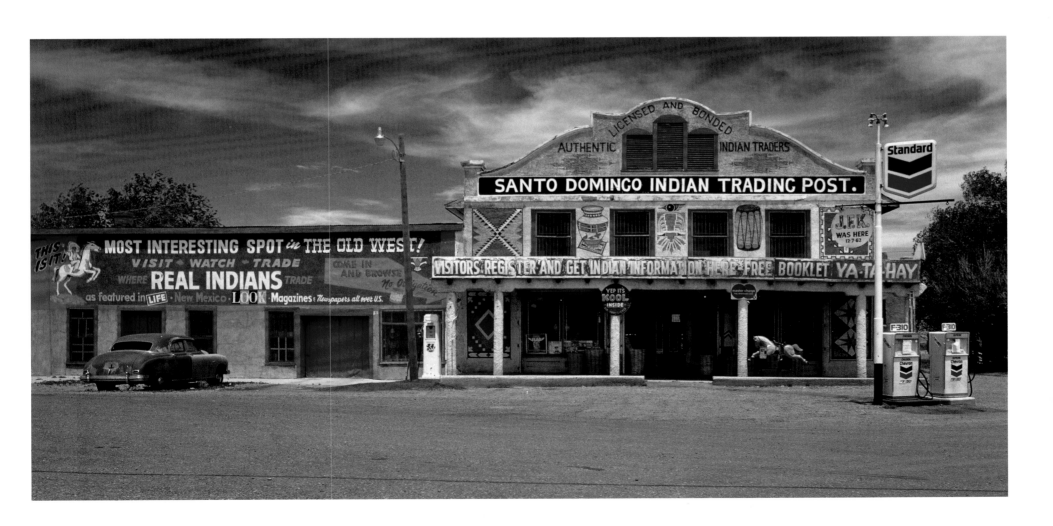

Ford Wagon Rolling Into Erik, Oklahoma 2006

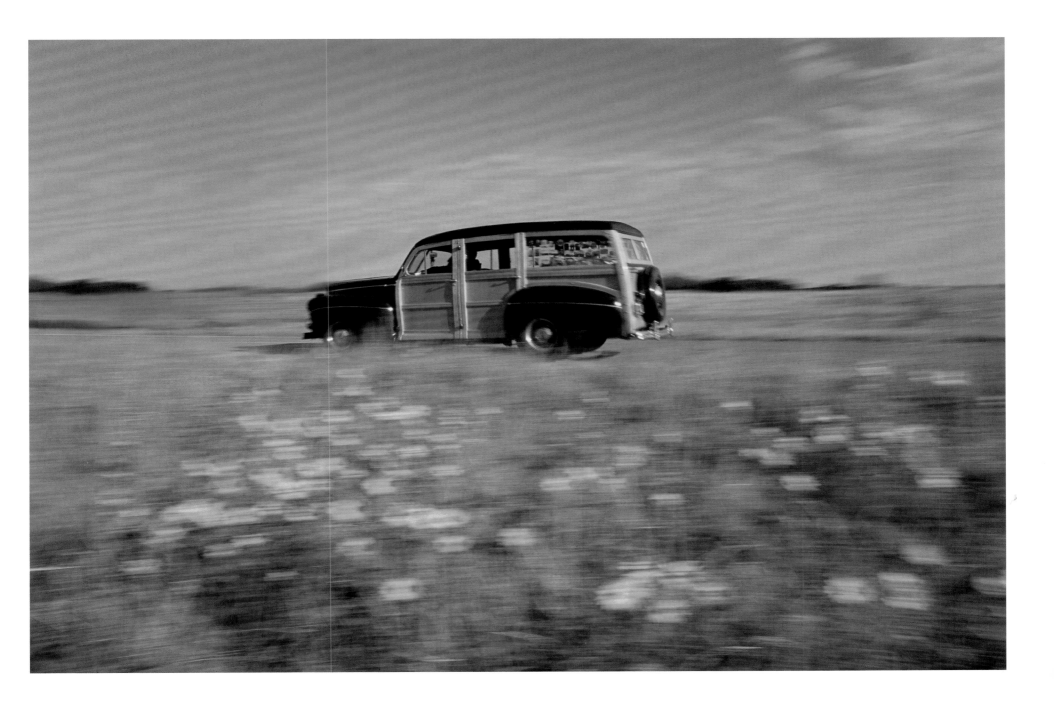

The Blue Cadoo
Cadillac Ranch, Texas 1984

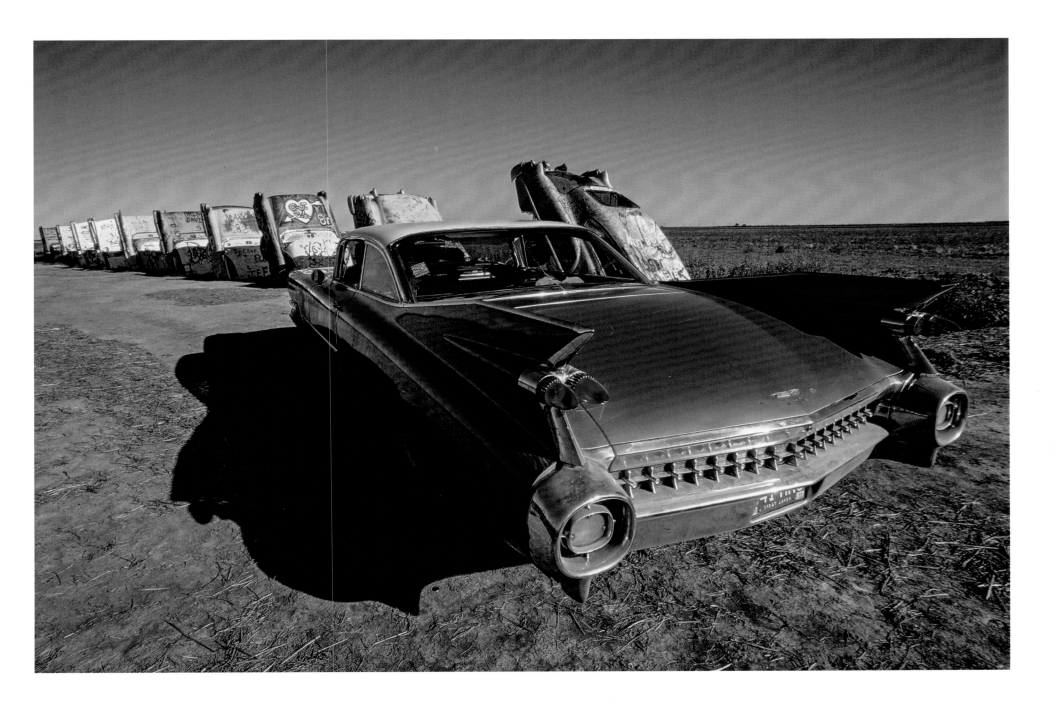

Highway and Parks Store

Parks, Arizona 1980

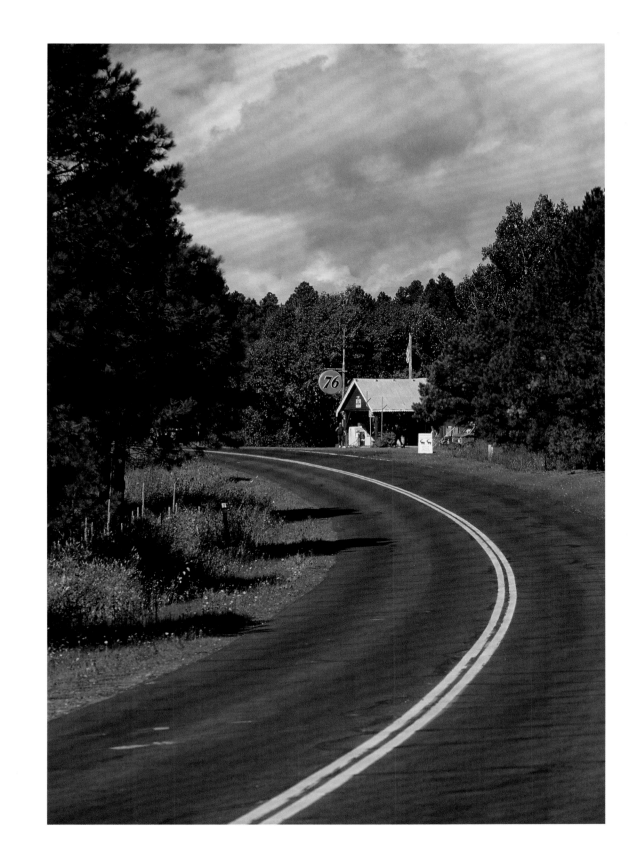

Welcome to Winslow

Winslow, Arizona 1972

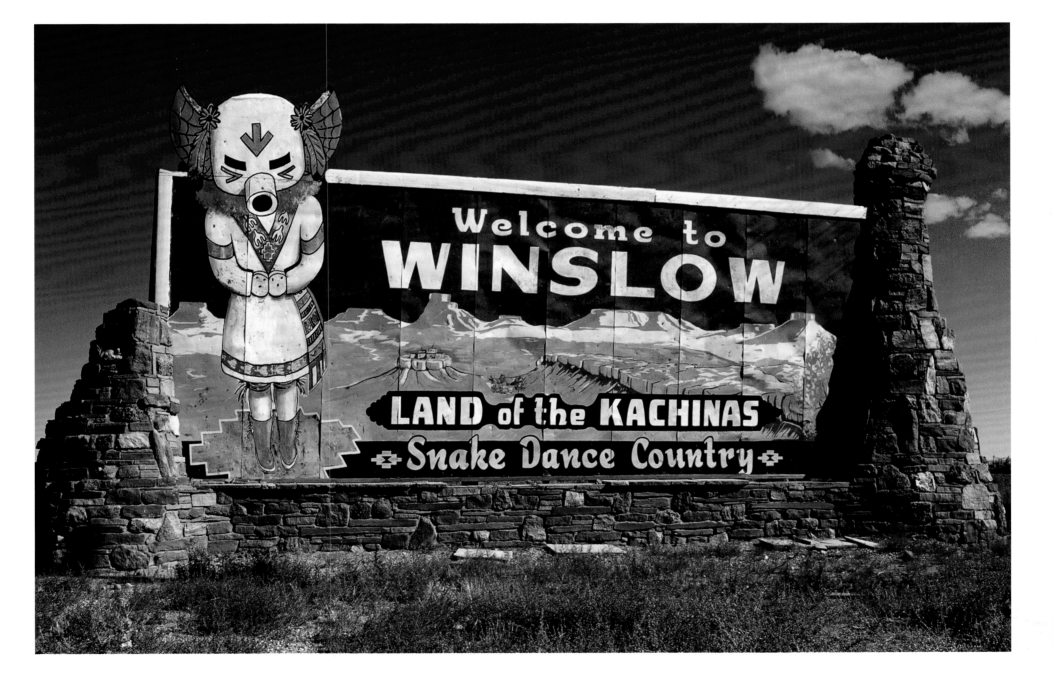

Blue Spruce Lodge

Gallup, New Mexico 2004

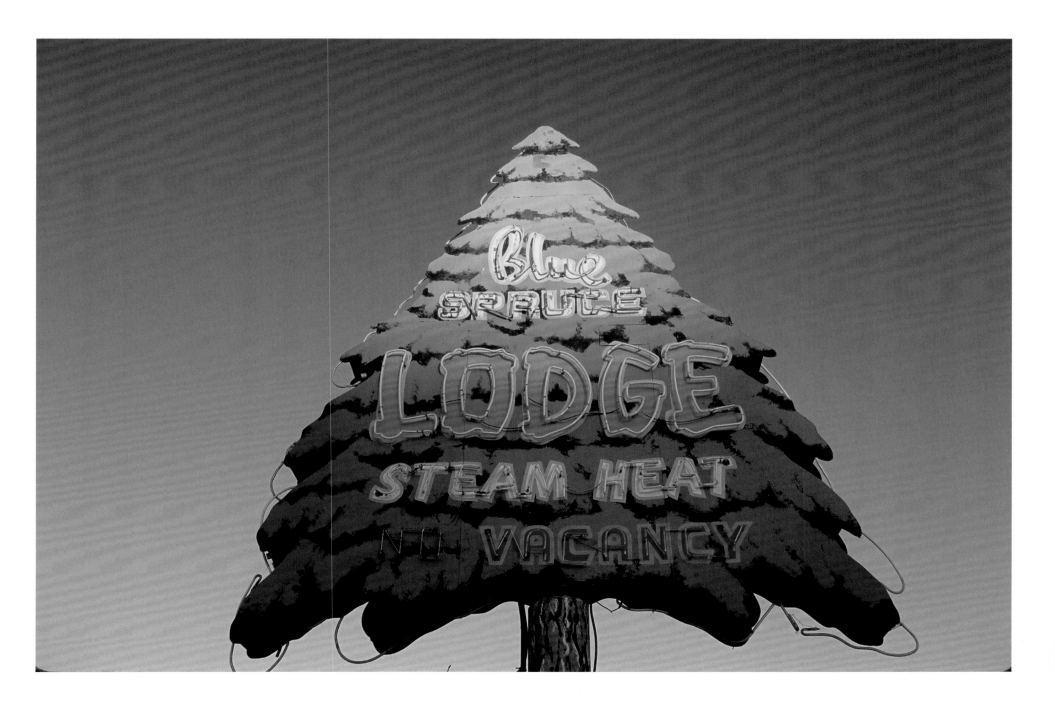

Neon Dancers on Sunset Boulevard

Hollywood, California 2010

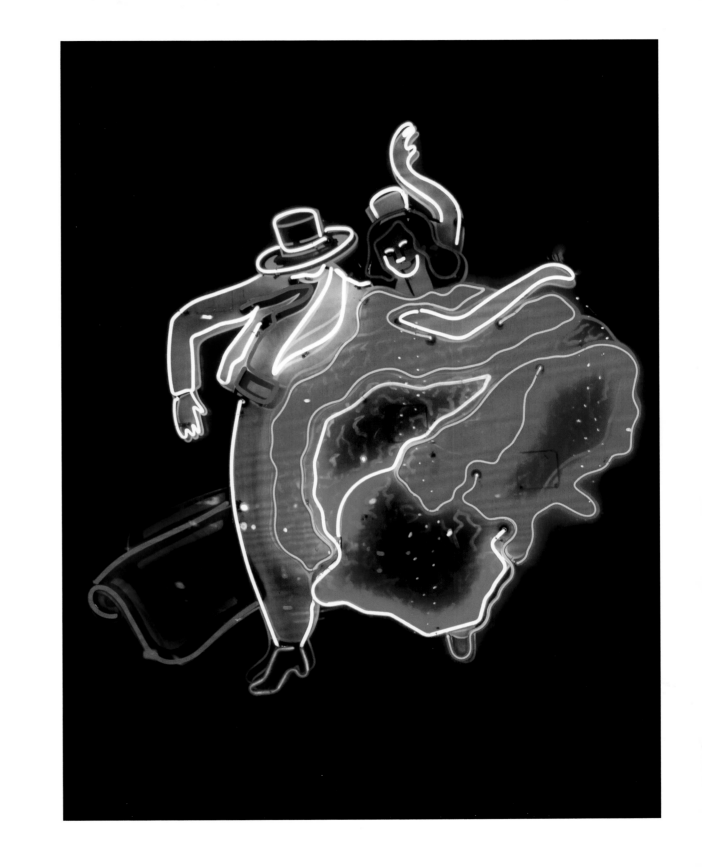

Kodak Film

Cubero, New Mexico 1970

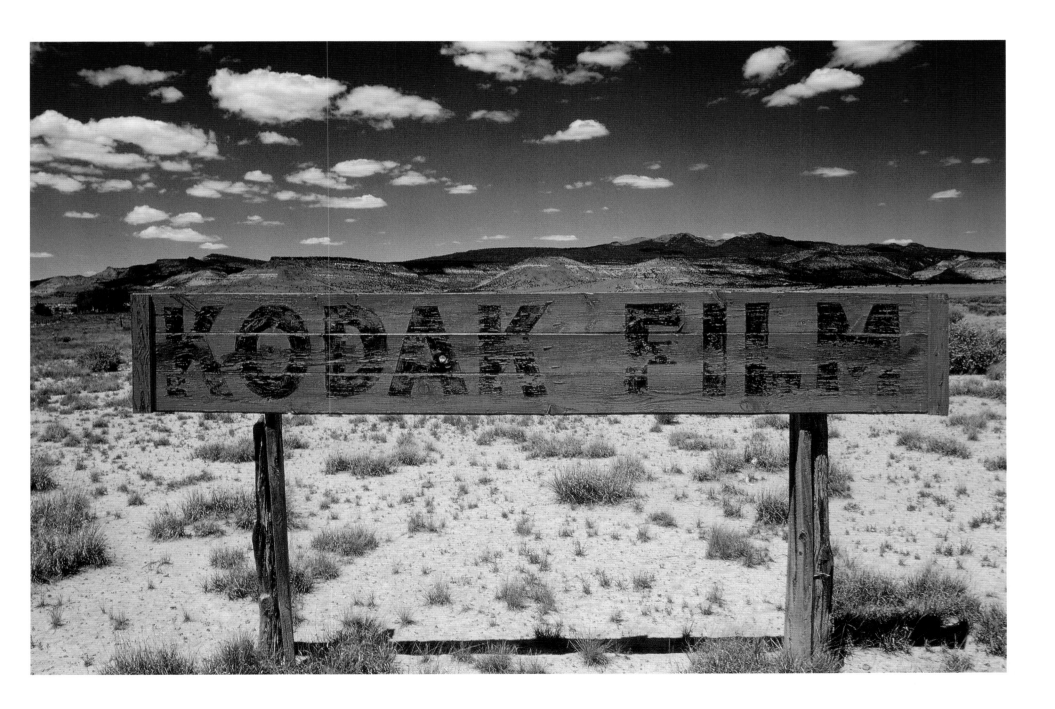

Old Trucks

Budville, New Mexico 2004

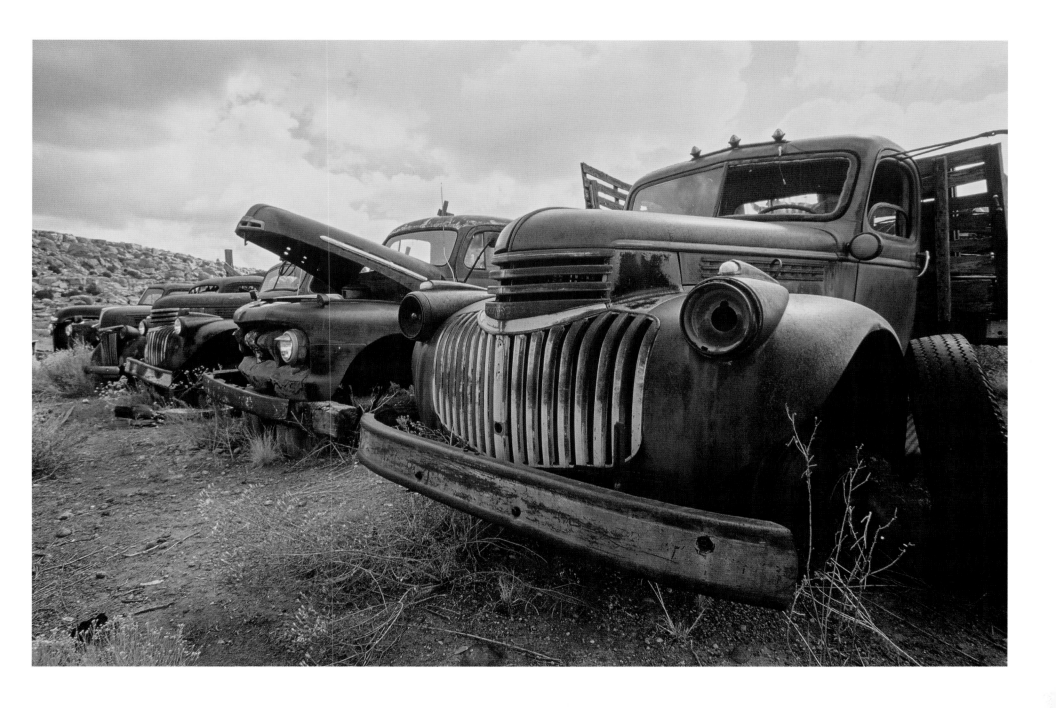

Figueroa Tunnels
Los Angeles, California 2010

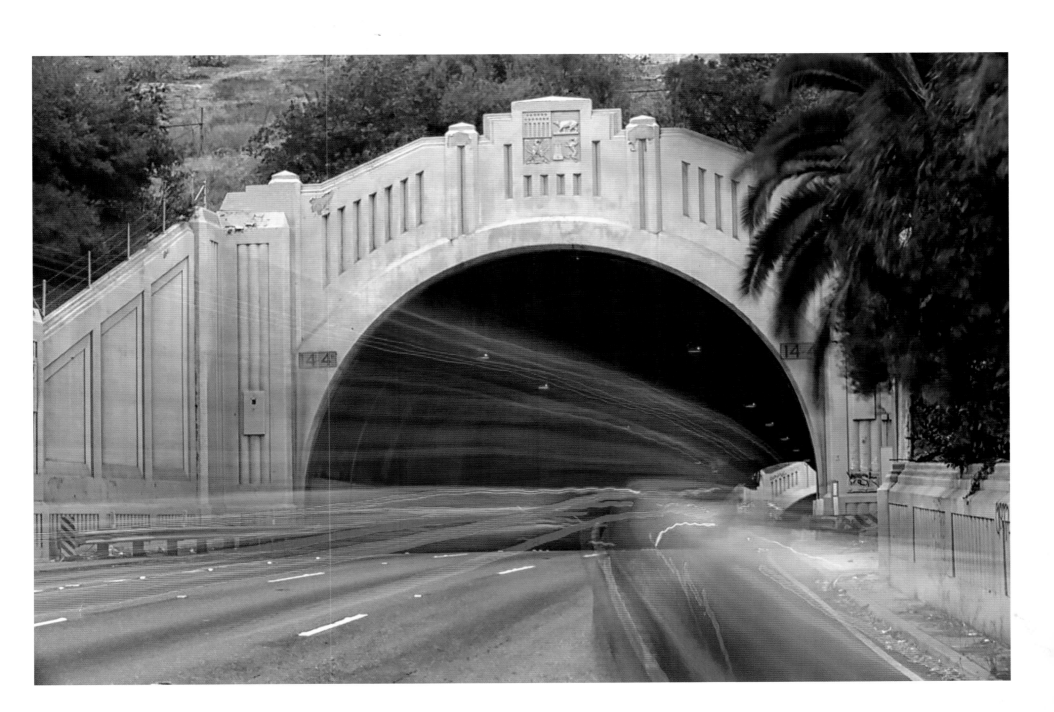

Mojave River Bridge

northwest of Victorville, California 2001

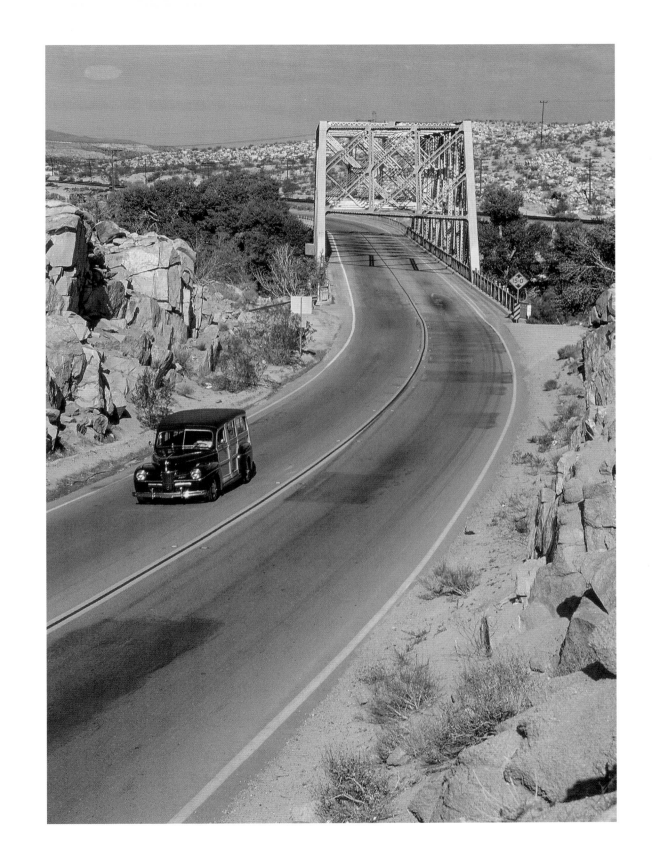

Hackberry Store

Hackberry, Arizona 2000

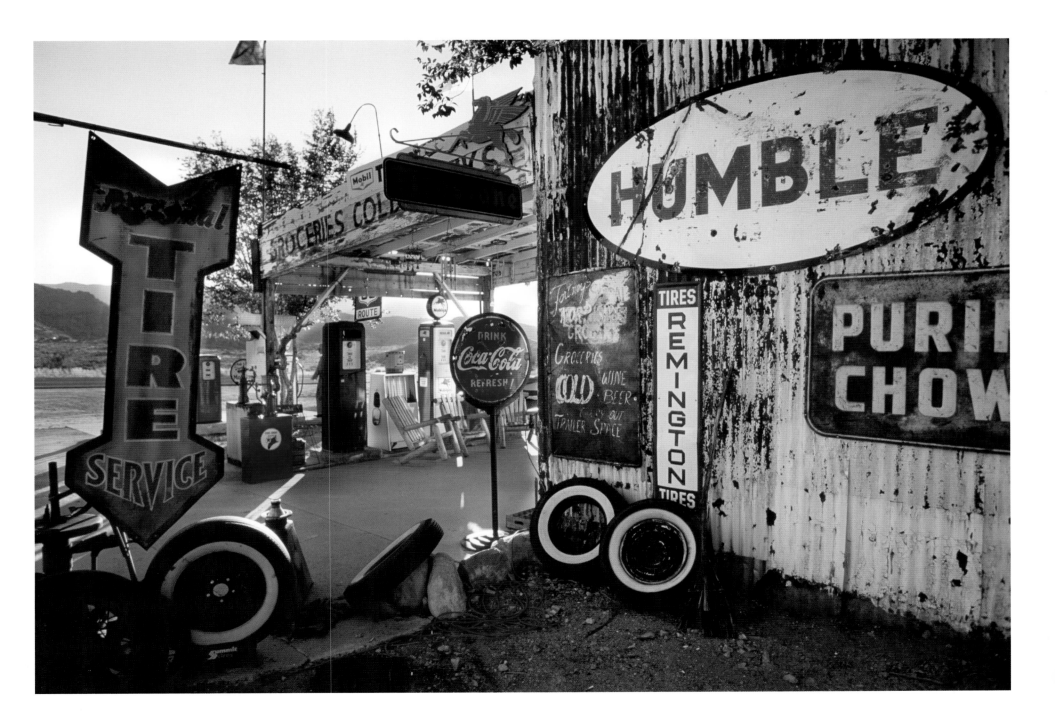

66 Courts and Elevator

Groom, Texas 1996

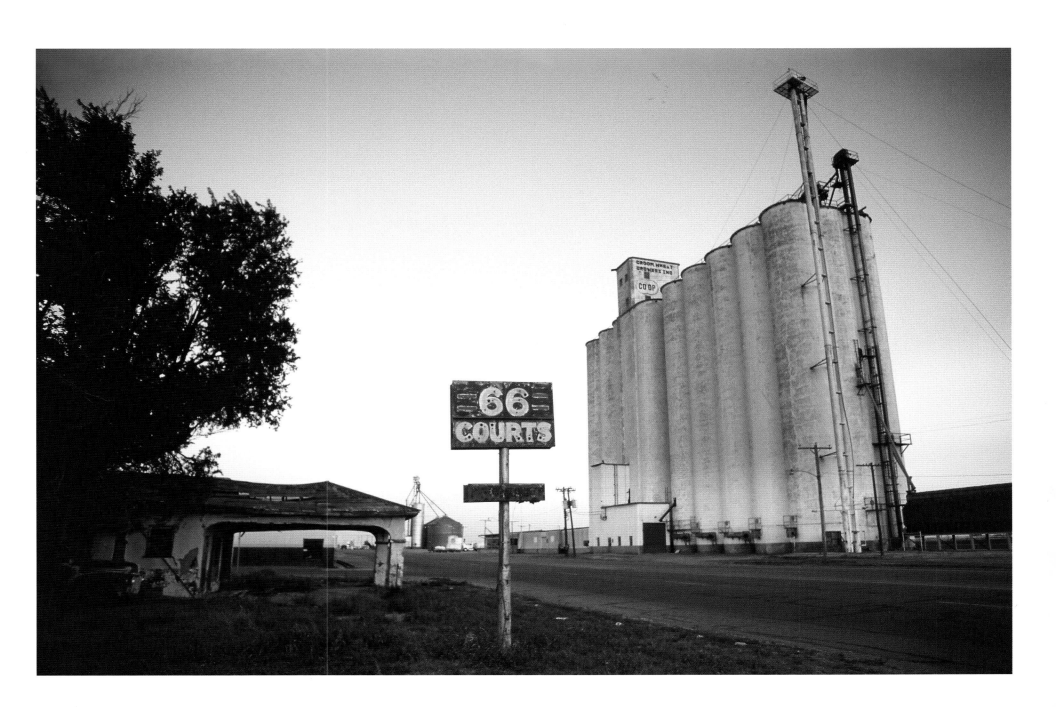

Will Rogers Motor Court

Tulsa, Oklahoma 1984

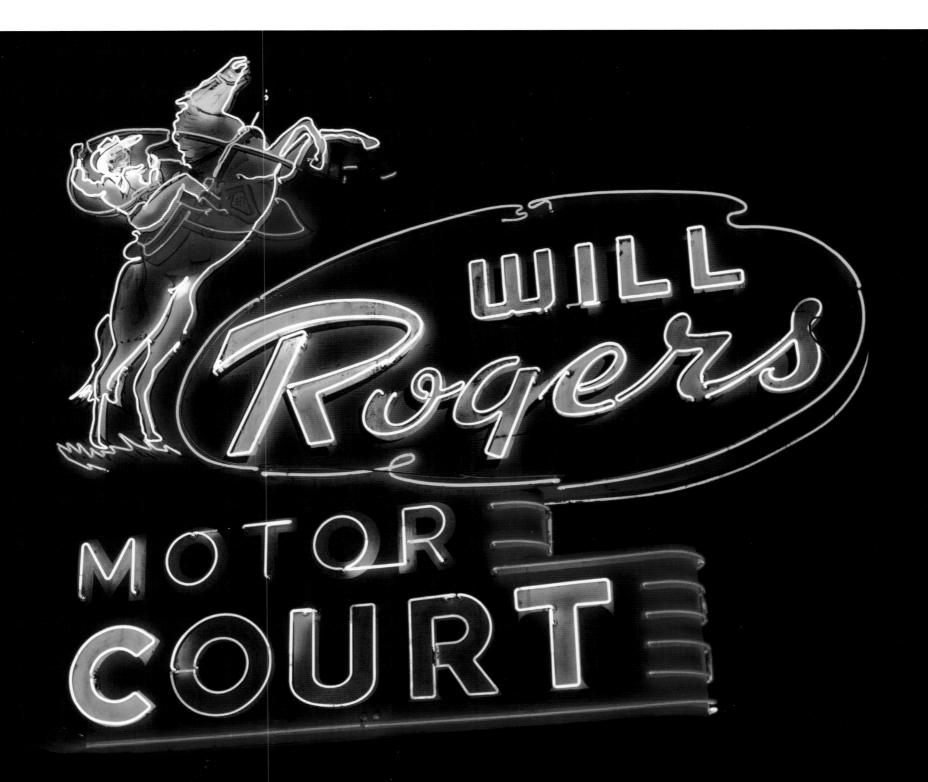

Casa Grande Motel

Albuquerque, New Mexico 1970

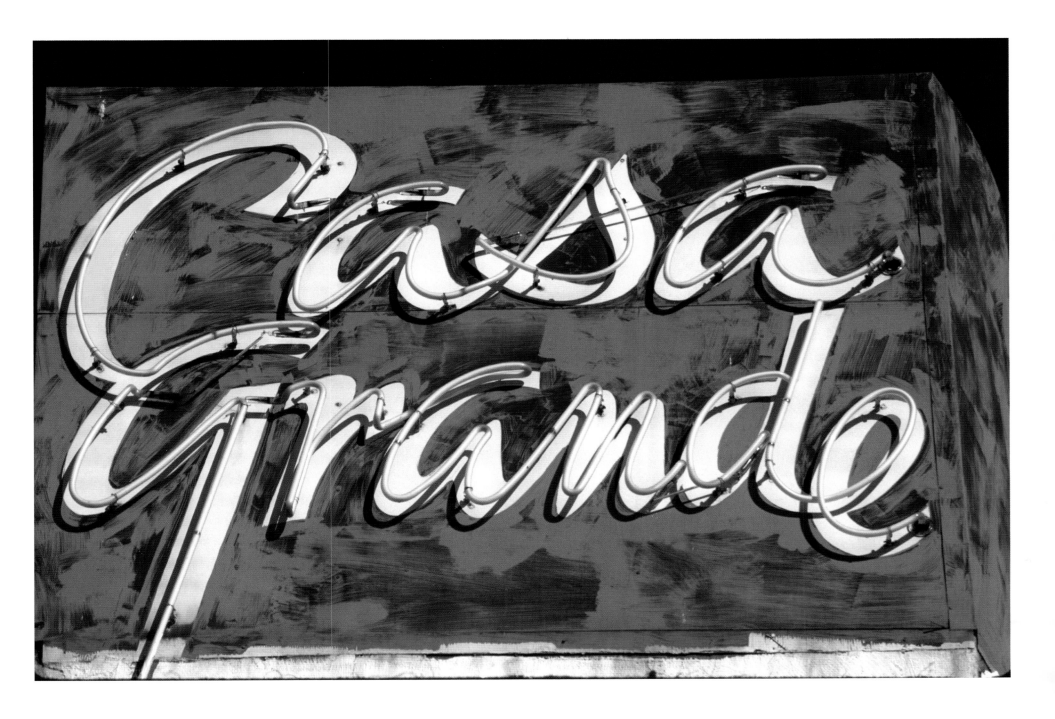

Roy's Motel and Cafe

Amboy, California 1988

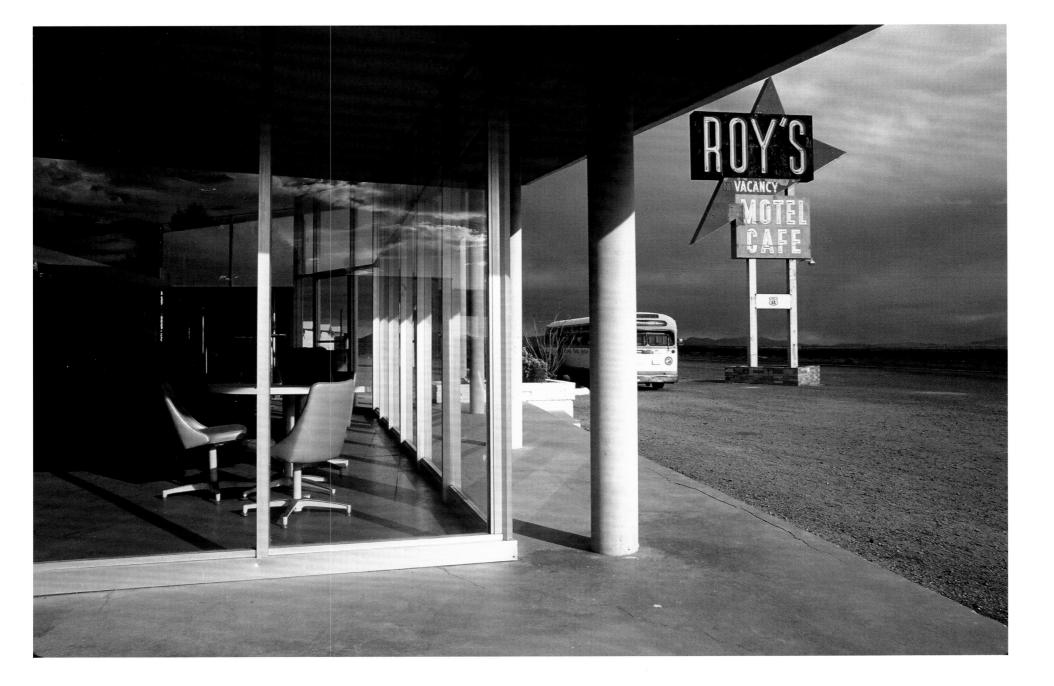

Dancers—Desert Hills Trading Post

West of Albuquerque, New Mexico 1971

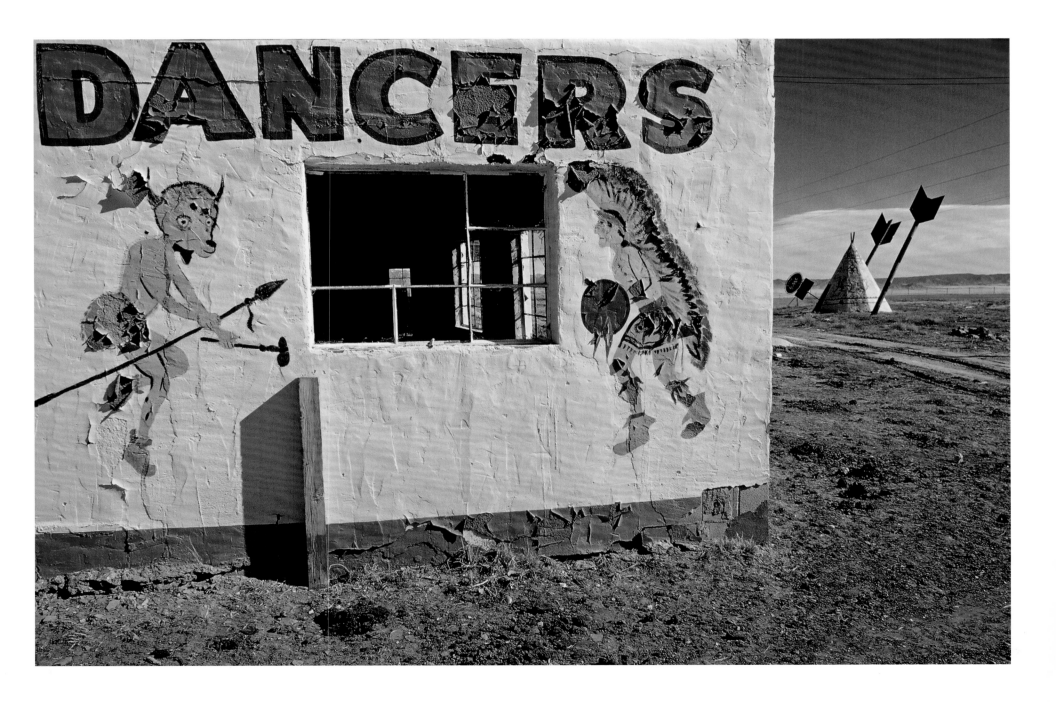

Calumet Flour Girl

Las Vegas, New Mexico 2004

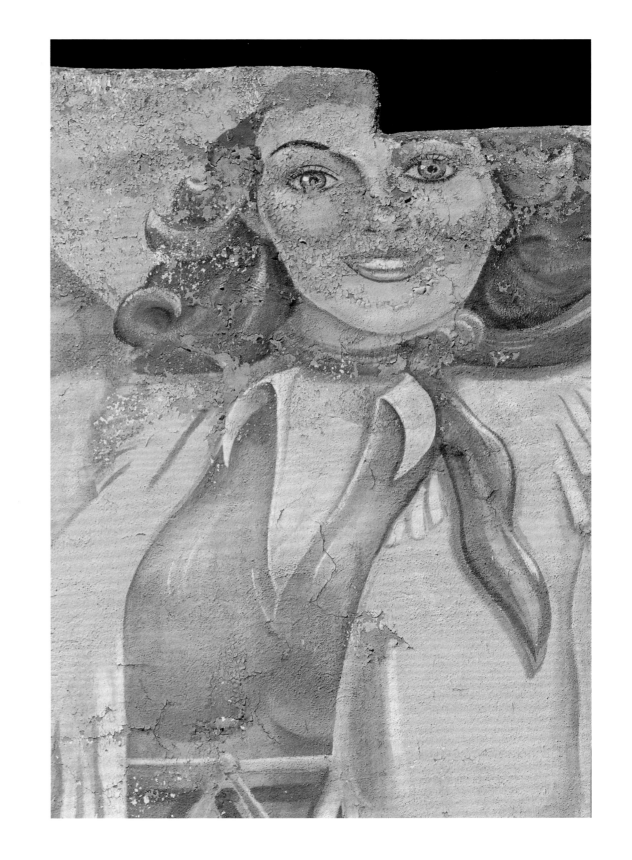

Rio Puerco Bridge
New Mexico 1996

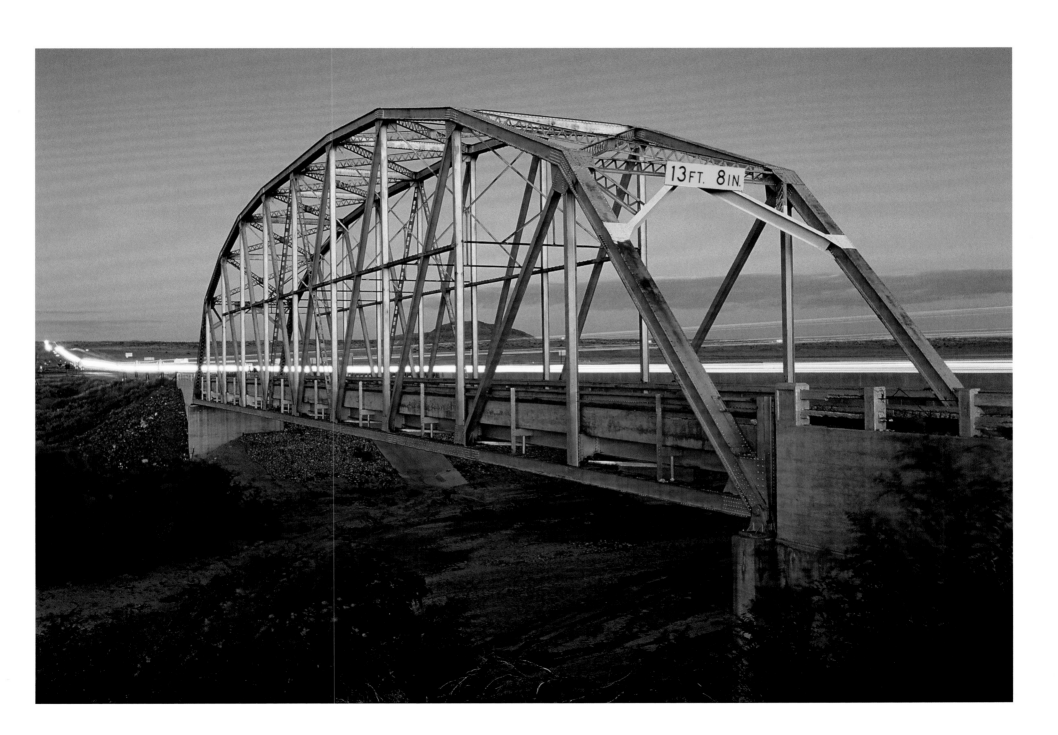

Road Sign

Mojave Desert, California 1976

The Golden Spur

Glendora, California 2002

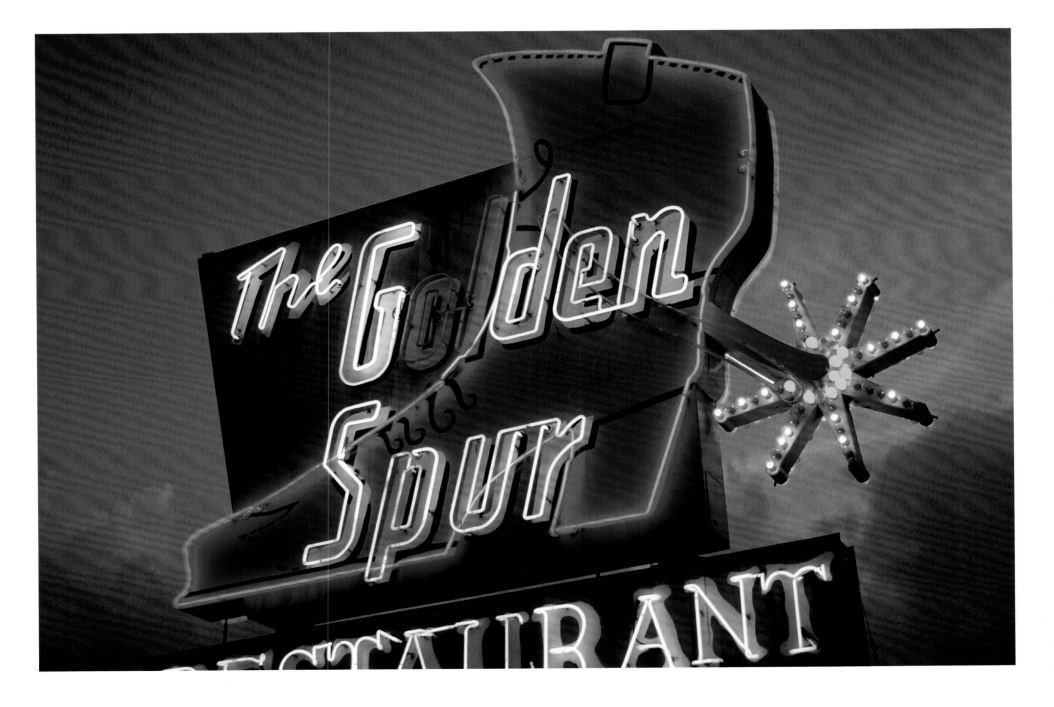

700 Miles of Desert
Kiva Trading Post, West of Albuquerque 1971

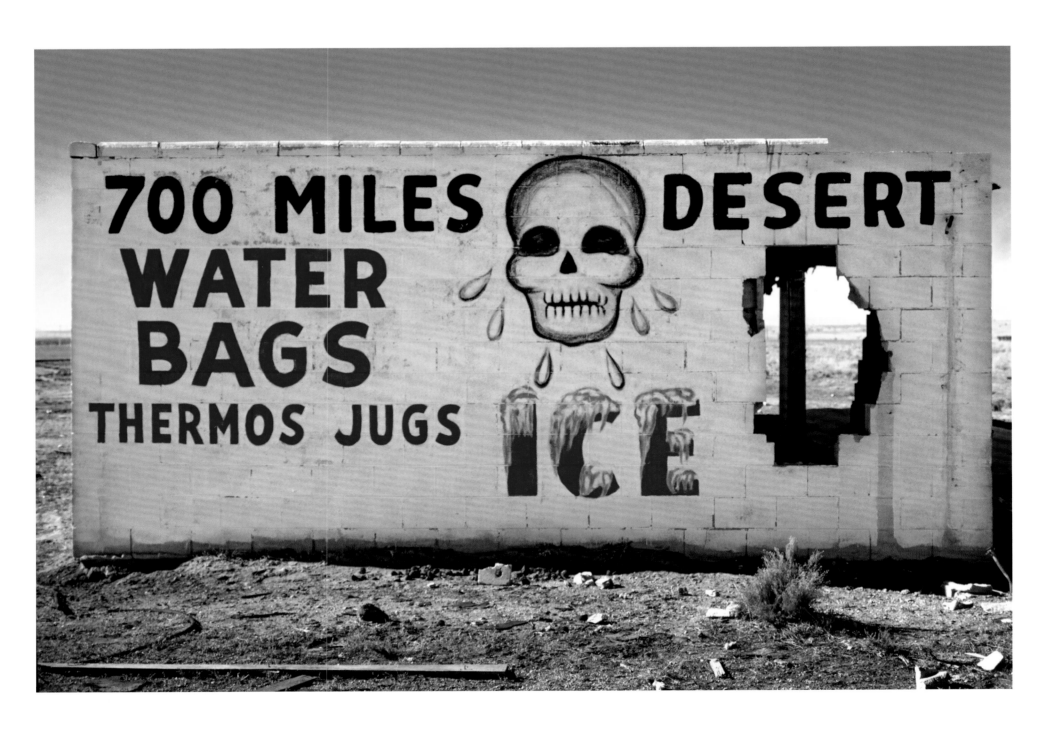

Chief Juan Yellowhorse
Lupton, Arizona 1999

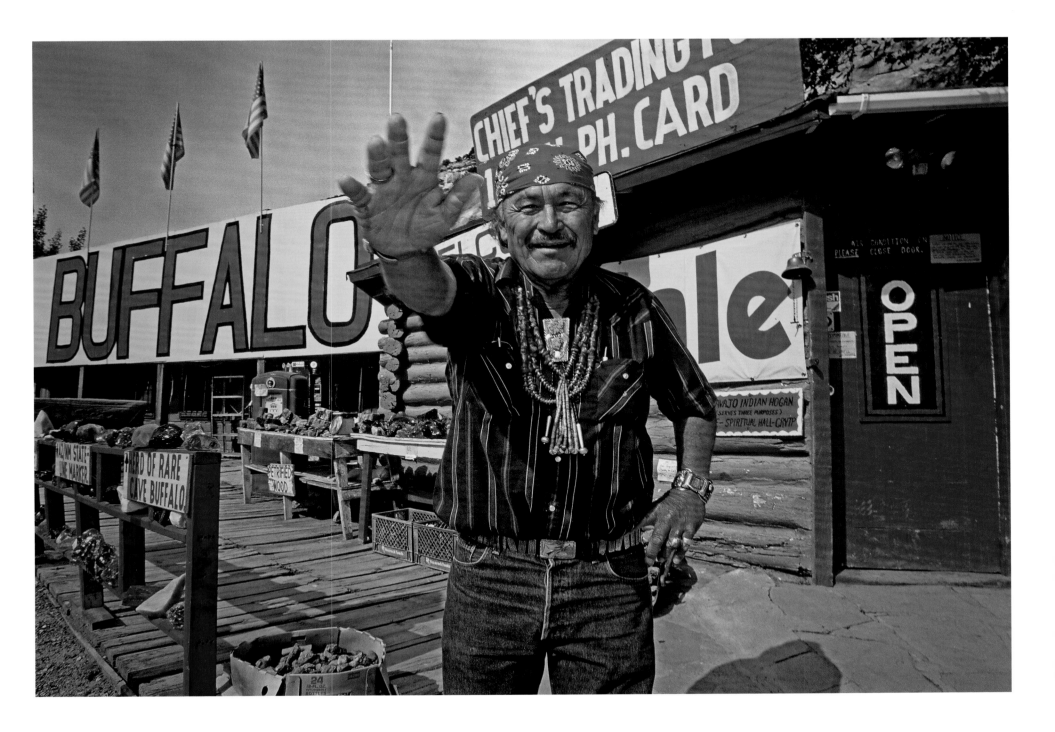

Ella's Frontier "The Oldest Trading Post on 66"

Joseph City, Arizona 1982

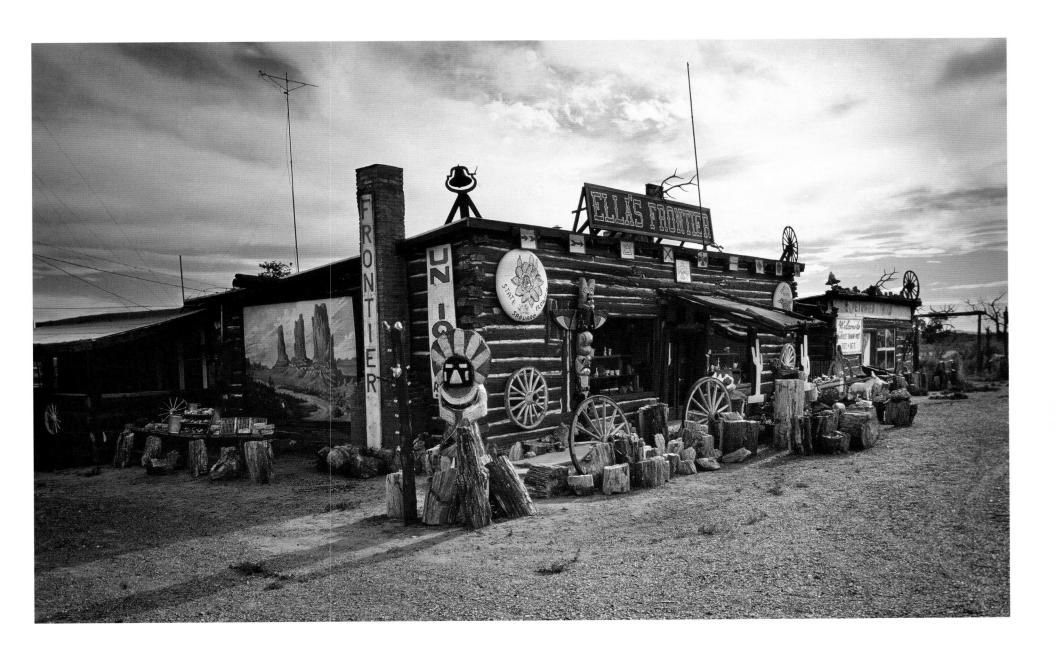

Copper Cart

Seligman, Arizona 2004

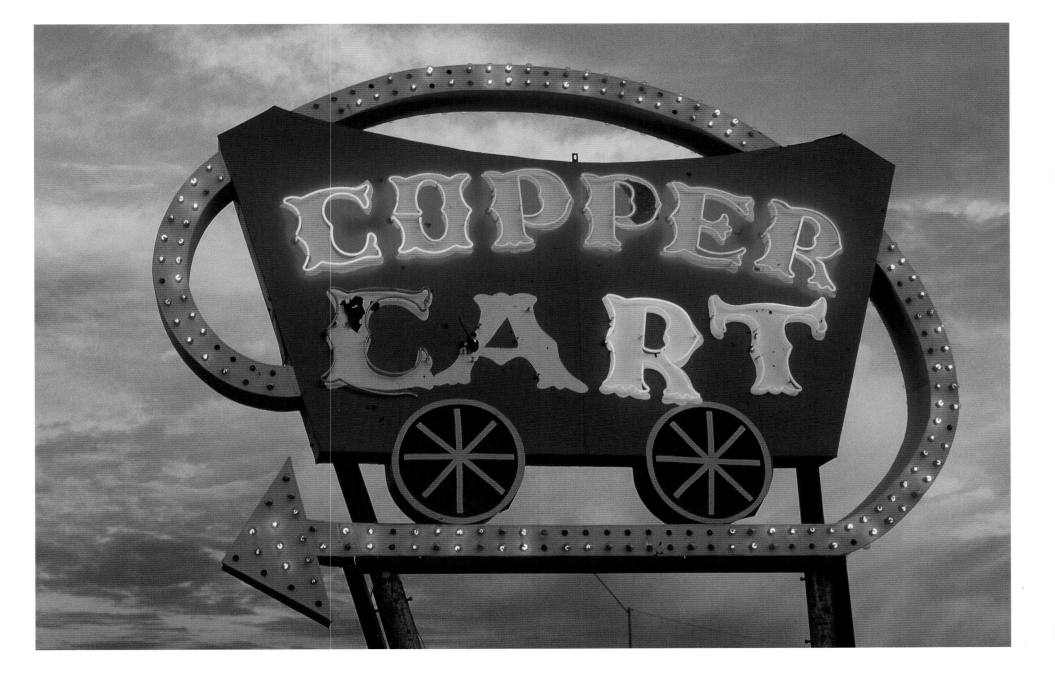

Sunset and Rain on the Cadiz Grade

Mojave Desert, California 1980

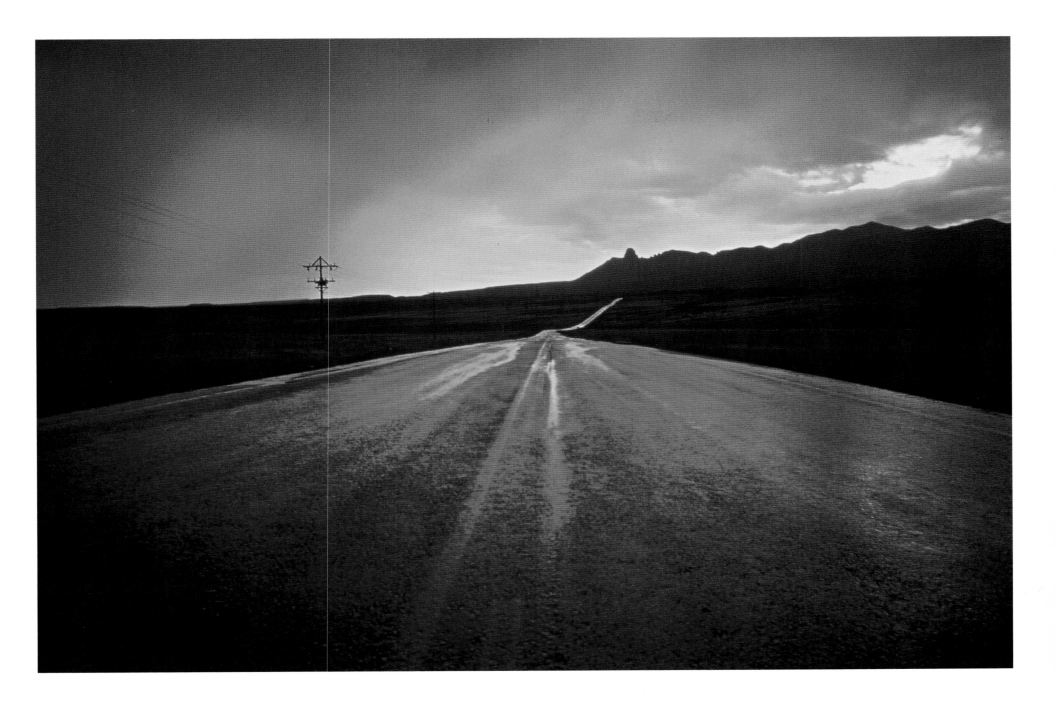

Cowgirl "Welcome to Arizona"

Topock, Arizona 1980

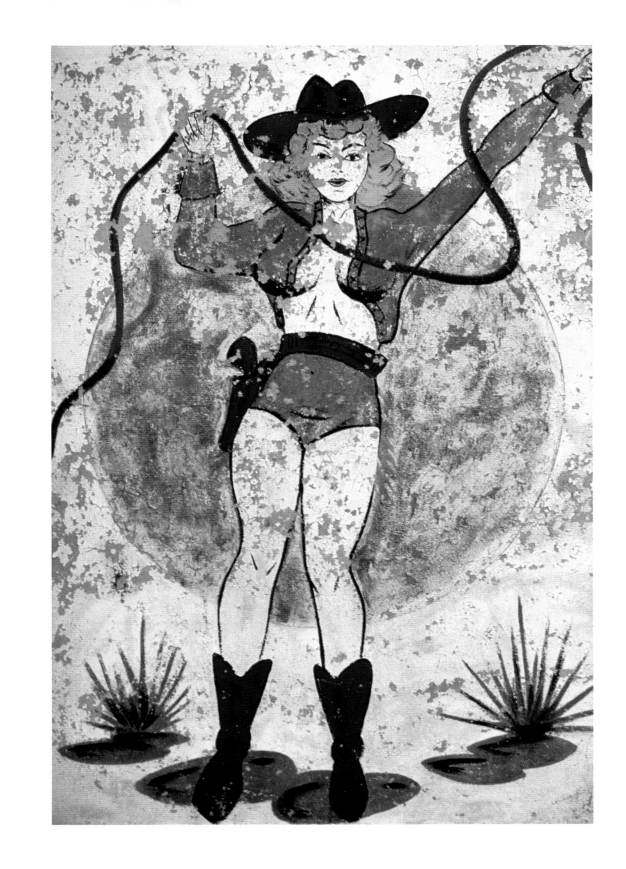

66 Neon on the Park-Inn Theater
Saint Louis, Missouri 1982

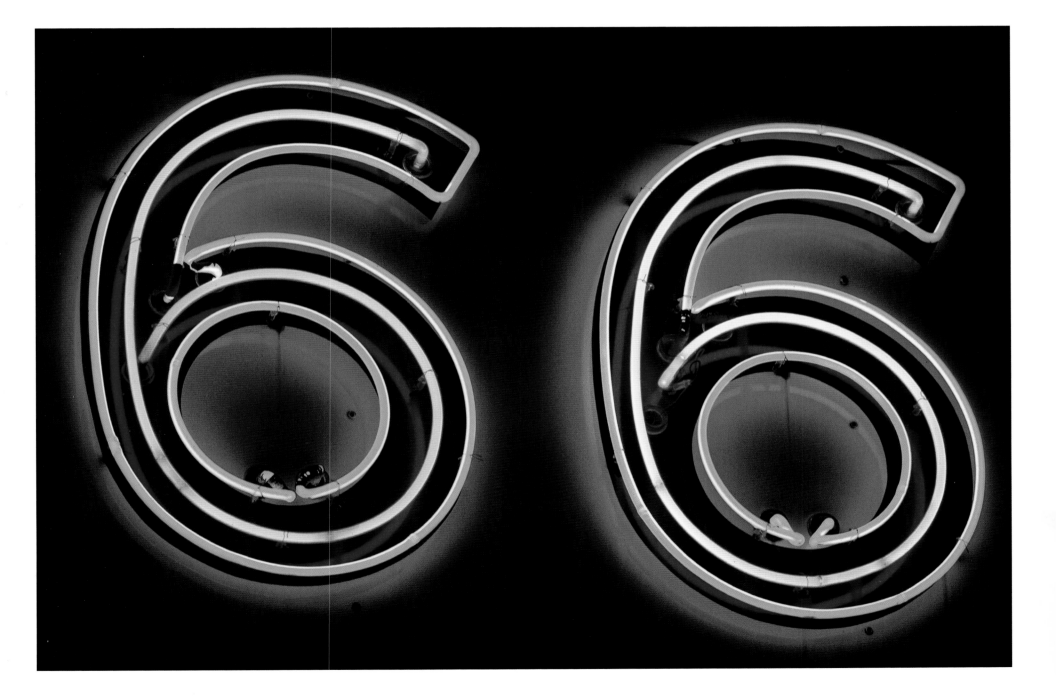

Star 6 Motel
Kingman, Arizona 1980

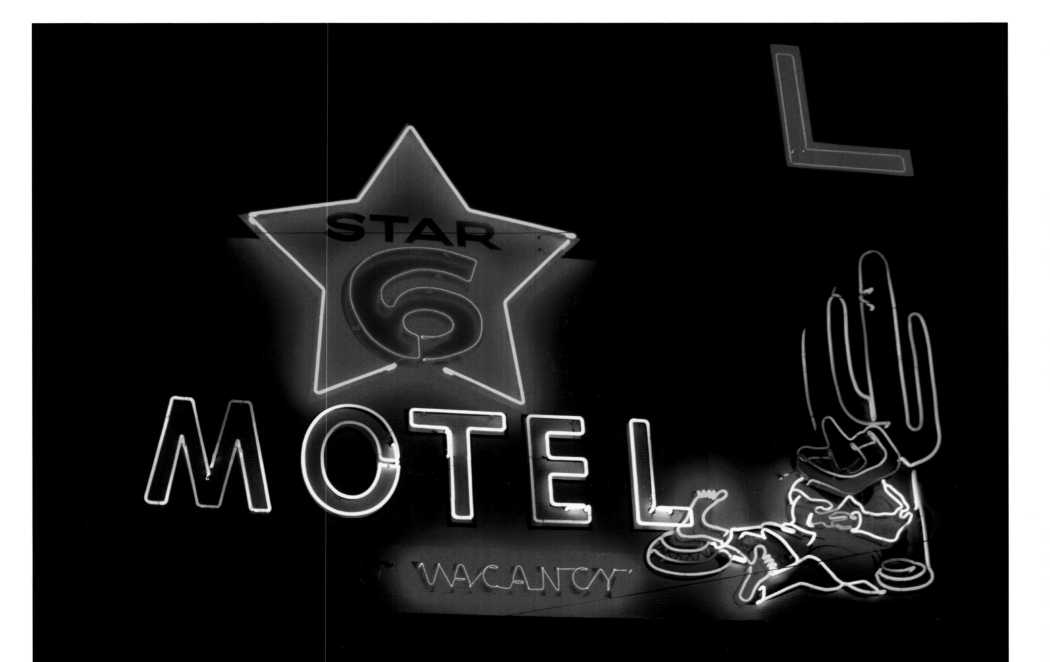

Looking West from Sitgreaves Pass

North of Oatman, Arizona 1999

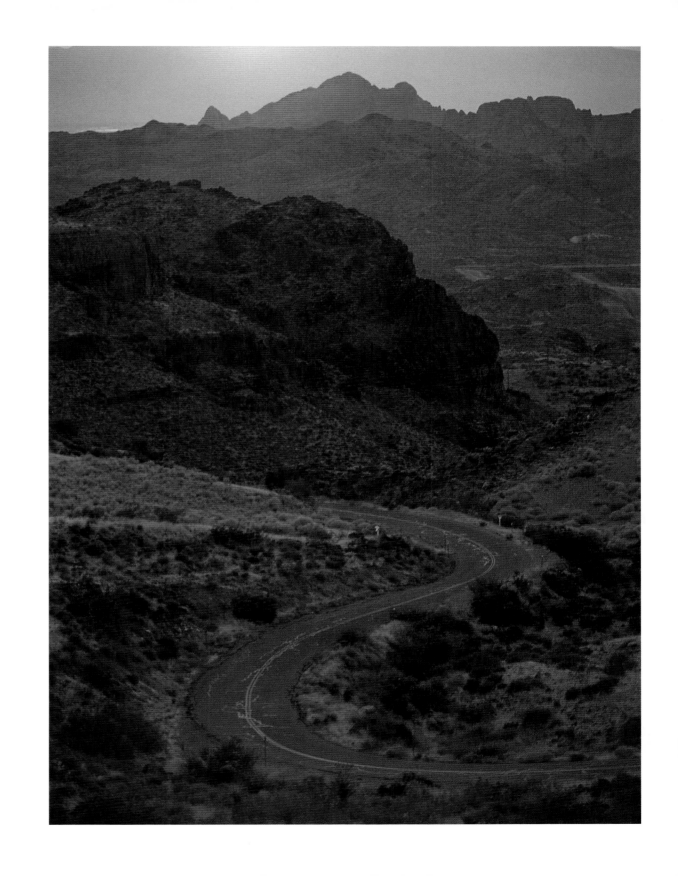

Texaco Gas Pumps
Conway, Missouri 1982

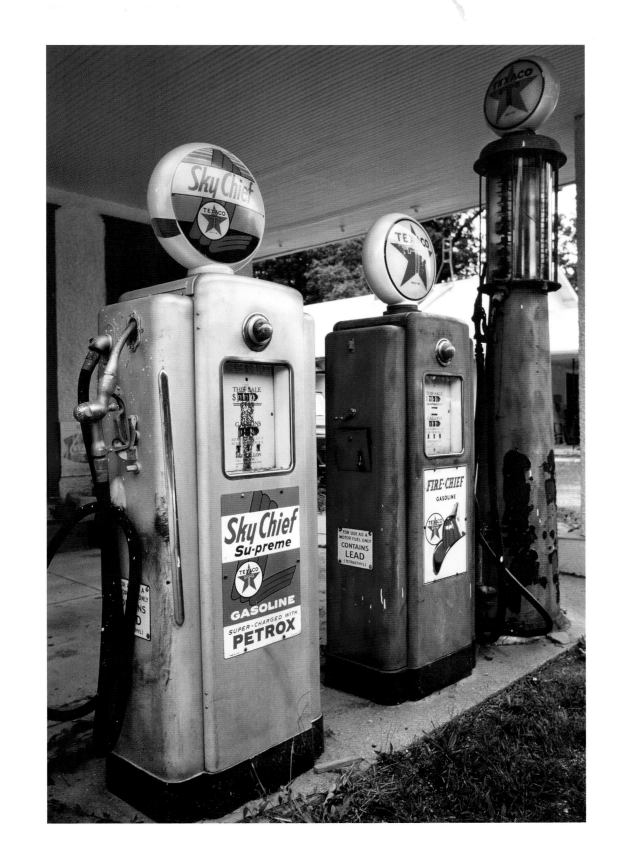

Entrance to the Santa Monica Pier

Santa Monica, California 2001

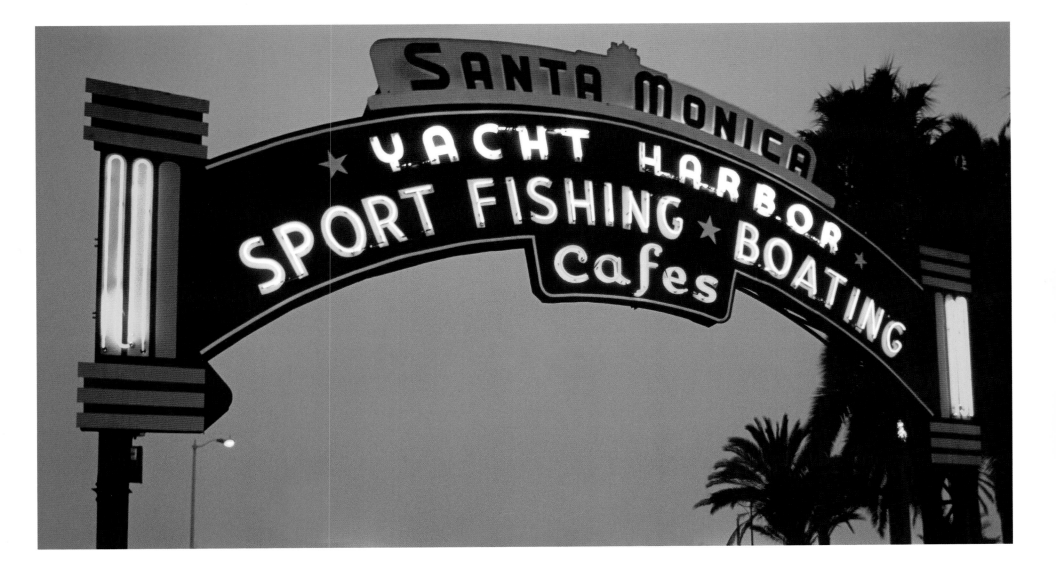

Santa Monica Boulevard and Bay
Santa Monica, California 1996

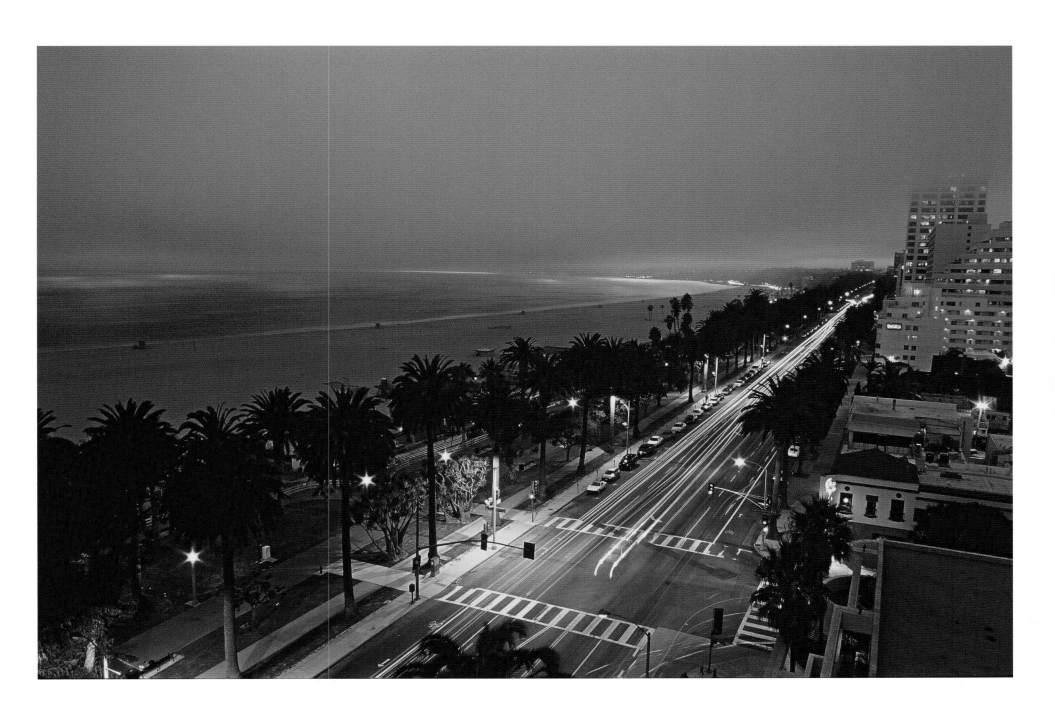

AFTERWORD

TERRENCE MOORE'S photographs preserve one of the greatest civic achievements of a new continent defining itself.

In essence, these photographs are nothing less than core documentation of the American 20th century.

Importantly Moore's work rises to incandescence in its description of an evanescent moment, when vibrant vernacular art in neon and paint grew up, then flourished alongside The Mother Road of America.

To the Okies and the Arkies, and to those millions who fled the upper Midwest and Appalachia from the 1930s up to the 1960s, America was a country depopulating itself and migrating westward.

We know these people intimately today due to the photographs taken by such artists as Dorothea Lange, Arthur Rothstein, Walker Evans, and all the other lesser known photographers of the government-sponsored Works Project Administration during the Great Depression. What we are less familiar with are the documentation projects that began in California in the 1960s, initiated by a handful of American photographers like Terrence Moore.

IN THE 21ST CENTURY, a time of tweets and instant digital communications, how is it possible that there exists a project of art documents, by an exceedingly important American artist, that is still largely unseen?

In a project that began in the late 1960s, Terry Moore began to photograph Route 66, the most iconic road in America.

Decades in the making, Moore's documentation is one of the most singularly impressive projects ever to have evolved in this country. It links the vast East/ West topography of a continent to a country's abandoned rural roots. Moore's document *66 On 66* reaches across the imagination of a century.

Established on November 11th, 1926, US Route 66 was one of the original roads that comprised a continent-wide American highway system envisioned to connect the coasts of the Atlantic and Pacific oceans, and stretch two-thirds of the way across the continent for a total of 2,448 miles from Chicago, Illinois to Santa Monica, California.

It was not until thirty years later, during the Eisenhower period, that these highways, now called "The Interstate Highway System," were delineated into new four-lane "freeways" that augmented the work first begun in the 1920s.

With this new iteration of progress in a restless country where nothing was impossible to engineer or build, travelers could now cross America in a few days and not weeks.

In the new four-lane version of America that emerged, the fact that town centers along the older highway were progressively bypassed by the new freeways seemed to have largely gone unnoticed. For older versions of a rural America however, this change was seismic in its consequences.

Away from the large cities, the old towns, along with whole villages nestled beside America's now suddenly irrelevant river-linked transportation systems, were bridged and abandoned by the new freeways. In the new business models, which had even created a new breed of social engineer called "management consultant," the super-highways of America generated companies like Walmart that emerged in the heartland.

In a devastating consequence of modernity, older versions of rural America, along with their cultures, were now cut off and isolated in the center of the country.

I FIRST MET Terry Moore in the mid-1960s.

My three brothers and Terry, in their sandblasted, dilapidated retro cars, attended a newly established institution of higher learning: the College of the Desert, otherwise known as COD. It seemed to me that the College of the Desert had appeared spontaneously. It had been built in just over 6 months in a California town named Palm Desert, a place that supported a few water-starved trees, a dangerous-and-difficult-to-cross six-lane highway that unpromisingly cut the town in half, and absolute brain-busting summer temperatures of up to 124 degrees.

Terry Moore was 21 years old and I was 25. We were both interested in documentation projects, and both of us in 1965 were attempting to work in an art world that had no interest whatsoever in photography. At that time only three people that I knew of in Southern California were making pictures of the social changes and realities of California. They were Dennis Hopper, Ed Ruscha and myself.

In 1965 Ruscha was working as a layout artist for *ArtForum Magazine*, and it was Charles Cowles, the owner of the magazine, who had introduced me to Hopper. In the early 1960s Ruscha had made photographs along Route 66, which he'd collected and published in his iconic work *Twenty-Six Gasoline Stations* (1963). It became our lodestar.

As photographers in California during the 1960s, Moore and I documented the changes wrought by this vast national

experiment. The central questions of our work became: "How could people not notice what was happening to rural America? In the future would anyone ever be interested in what America had been in its earlier versions?"

Along Route 66 both Terry and I became connoisseurs of extraordinary, killing heat. In the vastness of the western deserts, Terry was the only other person I knew who loved deserts the way I did. We both chose to take pictures in places where we should have been forbidden from going. Three years later, Terry was out there in the blinding heat beyond San Bernardino, moving eastwards, while I was in Ethiopia making the first photographs of the Danakil Desert, the most dangerous place on earth and the hottest. It was the only place on the planet with heat more extreme than the California desert.

In the decades ahead, Terry kept at the work. He continued to be possessed by this strange fascination for Highway 66, a road stretching off into the vastness of the great American desert. For years he traversed the hallucinations of thousand-mile heat waves that radiated from broken mountains and empty, long extinct watercourses. Beyond Palm Desert, in the terrible remorseless landscape of the western desert, a fearsome place traversed by Route 66, unwary travelers died when their cars broke down and their water ran out.

In the 1960s, and into the 1970s, Terry's work carried him again and again into the desert reaches of Route 66 as he kept pushing eastward. Few places on earth have the variety of landscapes spanned by Route 66. The highway literally traverses the bottoms of whole oceans subsumed by time, and mountain chains thrust upwards in ancient geological upheavals from below the earth.

He photographed the tired and broken wayside restaurants and the dilapidated "motor courts." He photographed the emerging, very temporary neon art of the bars, gas stations, motels, and tourist sites that advertised alongside the road. He passed through the increasingly isolated towns bypassed by the new freeways, and always the incredible landscapes through which the older parts of the highway lay claim.

At the verges of Route 66 he photographed the way the West had been, with its curmudgeonly survivors and the ancient homesteaders of the 19th century.

As Terry's work evolved, it became a self-conceived, self-funded document of the vanishing original Highway 66, the Mother Road of the American highway system. Eventually this work with its patina of time became an eloquently lavish, even operatic narrative of a five-decades-in-the-making text of vanished places. It was a project that, even at the time it was conceived, was difficult to imagine in all its complexity, and that seemed almost impossible to execute as art. Serendipitously for Terry, it was the innovation of the Kodak Kodachrome color slide film—that has proved the most color stable and durable color film ever commercially produced— that provided the technological and creative impetus to spur him on his creative journey.

As unlikely as it seems today, at the moment Terry took up his project it was a peculiar moment in the 1960s. In the American art world, only a few institutions considered photography an art worthy of museum exhibition.

For the historians and artists of the future, Terry's document is an essential document of the architecture, the townscapes, and landscapes that once populated a narrow strip of macadam that stretched across a much younger America.

Somehow, Terry stayed the course with his project. Today his work is as immaculate a conception as it was when he was 19 and began with cold implacability his long decades of work. What artist has ever had this large a canvas to work upon?

From its conception in the mid-1960s, through the end of the 20th century, and now into the 21st, Terry's project has also been a race against a new American future. Terrence Moore's project *66 On 66* is a memorial to a vanished time and place.

Clark Worswick,
2018

THE AUTHORS

©DAN BUDNIK

TERRENCE MOORE has been a professional photographer since his late teens, and is considered to be one of the premier landscape and architectural photographers of the southwest. He has published several books, among them *Desert Southwest* (with Paula Panich and Nora Burba), *Baja!* (with Doug Peacock) and *Under the Sun* (with Suzi Moore). Over the past five decades, he has contributed his images to such publications as *Smithsonian*, *American Heritage*, *Rolling Stone*, *Arizona Highways* and *The New York Times*, and his images can be seen in Michael Wallis's seminal book, *Rte. 66: The Mother Road*.

In reflecting on this book and the countless hours and miles he's spent exploring Rte. 66, Terry views the highway as integral to his life and the formation of his photographic career:

Ever since I was nine years old I have been a fan of Route 66. The Mother Road carried me and my family to the Golden State where we settled just off the highway in Claremont in the mid-1950s, when at that time the streets were lined with eucalyptus trees and citrus groves. I rode my bike on 66, went to high school on 66, bought my first car— a 1932 Ford—on 66, and by the time I got out of college and it was time to move on and away, I went to Albuquerque where I rented a cool old adobe just off 66 in Old Town. Albuquerque had just been by-passed by the new interstate system, so I headed out west of town to discover some of the trading posts, bars, and cafes that were still standing and that became my favorite subjects.

In the early 1970's, I continued taking a photo of the highway here and there, especially in New Mexico and Arizona. By 1976 writer Thomas Pew and I teamed up and ultimately did a series of "the End of Route 66" articles. Our first was for *American Heritage* titled "The Ghost Road of the

Okies" where we photographed and interviewed people who had made the trip to California during the Great Depression, including country western singer Merle Haggard's mother, Flossie. Later, I teamed up with *NY Times* writer Iver Peterson in 1984 for another "end of the road" article for *Rolling Stone*. We each chipped in $750.00 and bought a '59 Cadillac we named "The Blue Cadoo" and headed West.

In 1990 I contributed photos to *Route 66: The Mother Road* by Michael Wallis, an old traveling companion with whom I had taken numerous short trips on 66. By 1985, when the highway was decommissioned, all of us 66 fans were saddened by the fact that it was no more...or so we thought. Now, over thirty years later, Rte. 66 has been named a National Historic Highway, and there are new roadside businesses springing up every day, signs are being restored and people from all over the world have come to experience the Mother Road for themselves. As the ultimate highway icon it is still the great American road trip. So, I invite you to climb aboard and enjoy these photos, most of which have never been assembled into a single volume before, representing fifty years of my travels and photography.

Terrence Moore
Tucson, Arizona 2018

MICHAEL WALLIS is a bestselling biographer and historian of the American West as well as a storyteller who likes nothing better than transporting audiences across time and space. He has published nineteen books, including the award-winning *Route 66: The Mother Road*, the book credited with sparking the resurgence of interest in the highway. Wallis also is a co-founder of the non-profit preservation organization the Route 66 Alliance, and remains an advocate for all historic roads and trails.

CLARK WORSWICK has been involved in making photographs for sixty years, writing about photography and curating photography exhibitions. He was the first ever Research Fellow at Harvard in both film and photography. His books have been named "Best of the Year" by: *The New York Times*, the *London Times*, the *Washington Post*, *The New York Times Magazine*, *Newsweek* and *Time*. For decades Worswick has been a supporter of Terry Moore's work on vernacular America that he believes to be some of the most incisive photography created in the last quadrant of the 20th century.

ACKNOWLEDGMENTS

WITHOUT THE HELP and camaraderie of the following people over the years this book would not have happened. I am most grateful to you all—here's to the open road!

Clark Worswick, Tim Schaffner, Michael & Suzanne Wallis, Iver Peterson, Tom Pew, Abigail Adler, Wendover Brown, Dan Budnik, Ann & Kathie Shelton, Bill Perkins, John Oliver, Erich Healy, Brian Eakin, Antonia Zima, Jeb Rosebrook, Bill Bolinger, Mike Jackson, Douglas Towne and the Society for Commercial Archeology, Bill Schmidt, Donna Darrow, Jim Schneeweis, Amy Inouye, Jody Field, Eric Temple, Ed Belknap, Juidth Becker, Roger Palos, Dave & Andi Welles, Gregory McNamee, Nina Musick, Jody Field, Joe Wojcich, Dee Lafferty and everyone at Tempe Camera, Jim Farber, Anthony Ribeau, Suzanne Silverman, Kevin Feming, Ron Warnick and *Route 66 News*, Dave O'Neil, Richard Barber, Suzi Moore-McGregor, Gary Avey, Pete Ensenberger, Barbara Denney and all at *Arizona Highways*.

Rainbows

East of Seligman, Arizona 1999

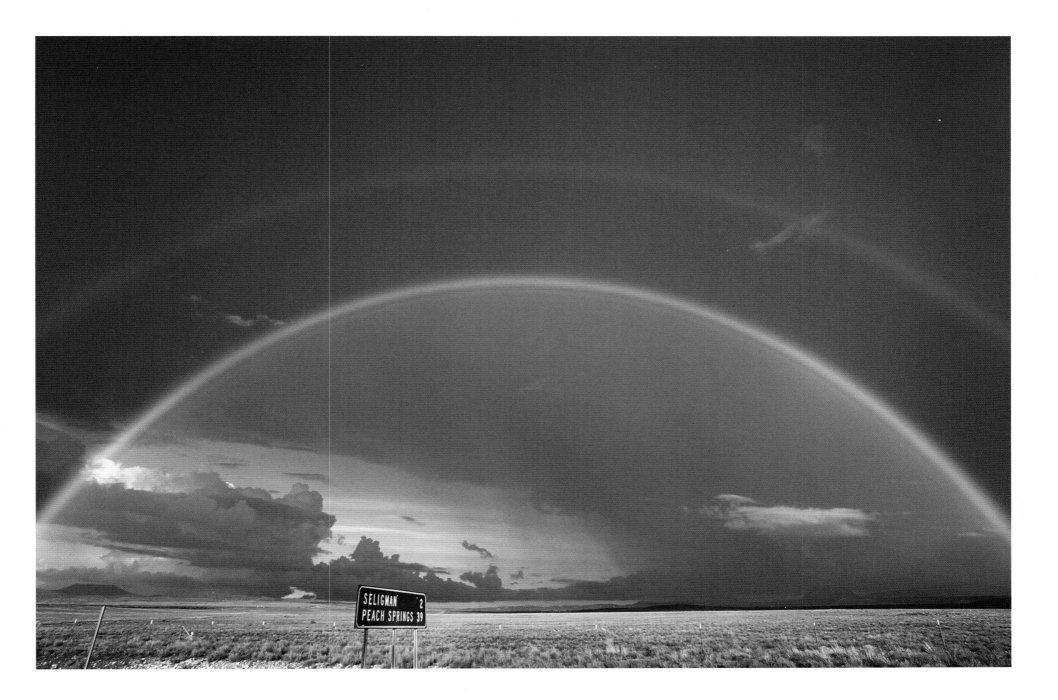

Arizona Rancho

Holbrook, Arizona 1978

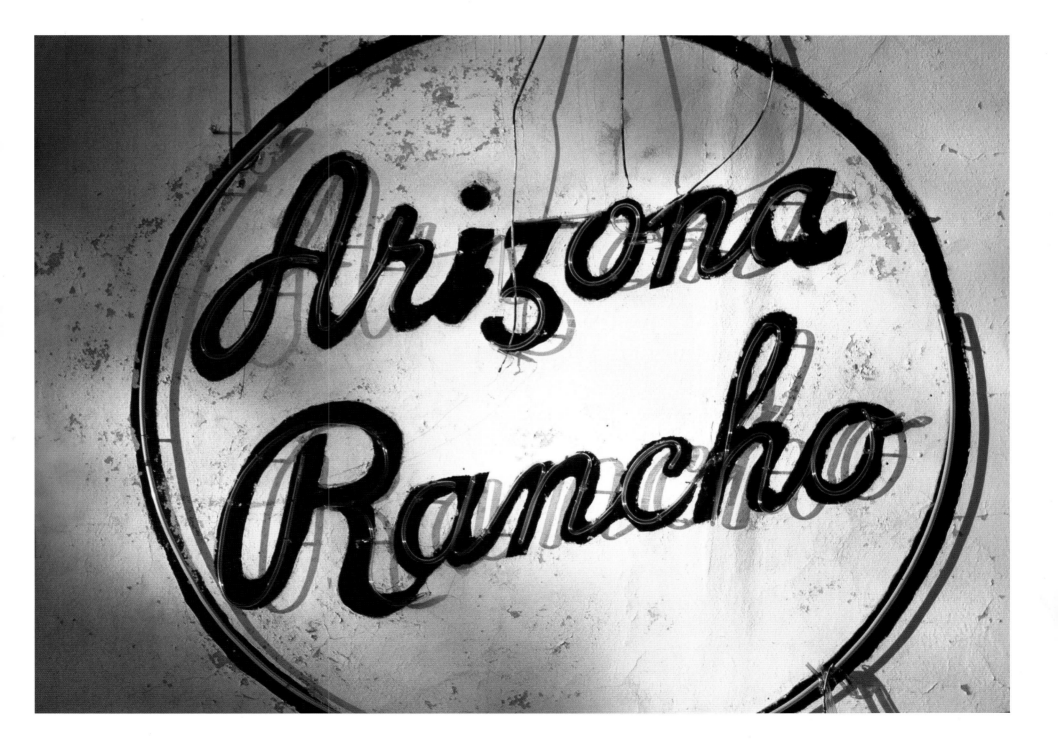